Jeanne Dunning STUDY AFTER UNTITLED

Heidi Zuckerman Jacobson

With essays by
Jeanne Dunning
Russell Ferguson

UNIVERSITY OF CALIFORNIA, BERKELEY ART MUSEUM AND PACIFIC FILM ARCHIVE

This book serves as the catalog for the exhibition *Jeanne Dunning: Study after Untitled,* organized by the UC Berkeley Art Museum and Pacific Film Archive.

Published by University of California, Berkeley Art Museum and Pacific Film Archive, Berkeley, California

Available through D.A.P./Distributed Art Publishers
155 Sixth Avenue, 2nd Floor, New York, NY 10013
Tel: (212) 627-1999 Fax: (212) 627-9484

Book Design: Mary Kate Murphy and Emily Wright
Editor: Judy Bloch
Associate Editor: Juliet Clark

Perry-Granger & Associates Print Management

COVER: Jeanne Dunning: *Study after "Untitled Landscape," 1987,* 1996 (detail)

Library of Congress Cataloging-in-Publication Data

Jacobson, Heidi Zuckerman.
 Jeanne Dunning : study after Untitled / Heidi Zuckerman Jacobson ; essays by Heidi Zuckerman Jacobson, Jeanne Dunning, Russell Ferguson.
 p. cm.
 Includes bibliographical references.
 ISBN 0-9719397-5-6 (alk. paper)
1. Photography, Artistic--Exhibitions. 2. Landscape photography--Exhibitions. 3. Portrait photography--Exhibitions. 4. Still-life photography--Exhibitions. 5. Dunning, Jeanne--Exhibitions. I. Dunning, Jeanne. II. Berkeley Art Museum and Pacific Film Archive. III. Title.
 TR647.D86J33 2006
 779'.092--dc22
 2005017707

Printed and bound in the United States of America
The paper used in this publication is acid-free.

TABLE OF CONTENTS

Jeanne Dunning: Study after Untitled presents a selective survey of Chicago-based photographer, sculptor, and video artist Jeanne Dunning. I have known and followed Dunning's work since 1990, when I was director of the Museum of Contemporary Art in Chicago and first saw images from *Heads* (1989–90). I have been impressed with the way her art has evolved in concept and execution over the intervening fifteen years. The Berkeley Art Museum's interest in featuring a mid-career exhibition of Dunning's work is related to our long-term commitment to showing artists who are creating significant work but have not been assimilated into the mainstream "art market."

Dunning's preoccupation with boundaries or borders, and her visual focus on skin as a metaphoric representation of the separation between internalized and externalized realities, is consistent. While she can be considered in the context of artists involved with identity issues, her work transcends a gendered reading, deriving its power from her deft tendency to visually universalize this information as physical or metaphysical. The content of Dunning's corporeal imagery is really about issues and meanings that are far deeper and subtler than one initially perceives, or that have shifted over time.

We are pleased and proud to be presenting and circulating this view of her work, selected and curated by Heidi Zuckerman Jacobson.

Kevin E. Consey
Director, University of California, Berkeley Art Museum and Pacific Film Archive

Jeanne Dunning is known primarily as a photographer, and it is on her extensive contributions in that medium, as well as her experimental videos, that this survey will focus. The essence of her work in all media is an ongoing exploration of vision and the inherent assumptions we make about what we see. Creating an exhibition with these works and ideas has been a gratifying experience.

Berkeley Art Museum and Pacific Film Archive Director Kevin E. Consey deserves credit for conceiving of the idea of presenting a major show of Dunning's work in Berkeley and traveling it nationally. With him, former Associate Curator Alla Efimova was responsible for laying the initial groundwork for the exhibition. I thank them both. I wish to thank as well my colleagues on the BAM/PFA staff for their hard work on the exhibition and the attendant catalog: Designer Mary Kate Murphy and former Assistant Designer Emily Wright, Editorial Director Judy Bloch and Associate Editor Juliet Clark, Director of Registration Lisa Calden, Exhibition Designer Barney Bailey, Education Director Sherry Goodman and Assistant Curator for Education Karen Bennett, and Director of Institutional Giving Elisa Isaacson and Assistant Director of Institutional Giving Ellen Martin. I would also like to acknowledge curatorial staff members Ellen Russell, Terri Cohn, and Miki Yoshimoto and interns Tanya Zimbardo and Jenée Misraje for their essential work on the exhibition. I especially want to recognize Jeanne Dunning's close involvement with the exhibition. It has been my pleasure to collaborate with her.

We are deeply grateful for the financial assistance of individuals and private foundations that have been extremely generous. The lenders to this exhibition are many, and their willingness to lend objects secured the success of the project. Finally, it is a great honor to work together with the Chicago Cultural Center, an institution that shares our interest in Dunning's work and will be presenting the exhibition after its close at the Berkeley Art Museum and Pacific Film Archive.

Heidi Zuckerman Jacobson
Former Phyllis Wattis MATRIX Curator, UC Berkeley Art Museum and Pacific Film Archive

FUNDERS

Peter Norton Family Foundation
An anonymous donor
Consortium for the Arts at UC Berkeley

LENDERS

The Broido Family Collection
Jeanne Dunning
Marty and Rebecca Eisenberg
Feigen Contemporary, New York
Carol and Arthur Goldberg
Sandy Golden
Harris Theater for Music and Dance, Chicago
Maria Makela and Neal Benezra
Lys Martin
Milwaukee Art Museum
Museum of Contemporary Art, Chicago
Museum of Contemporary Photography,
 Columbia College Chicago
Peter Norton, Santa Monica
Friedrich Petzel, New York
Clayton Press and Gregory Linn
Gloria and Paul Sternberg, Jr.
University Galleries, Illinois State University, Normal
Martin and Danielle Zimmerman

EXHIBITION TOUR

University of California, Berkeley Art Museum
and Pacific Film Archive
Berkeley, California
January 25 – April 2, 2006

Chicago Cultural Center
Chicago, Illinois
April 29 – July 2, 2006

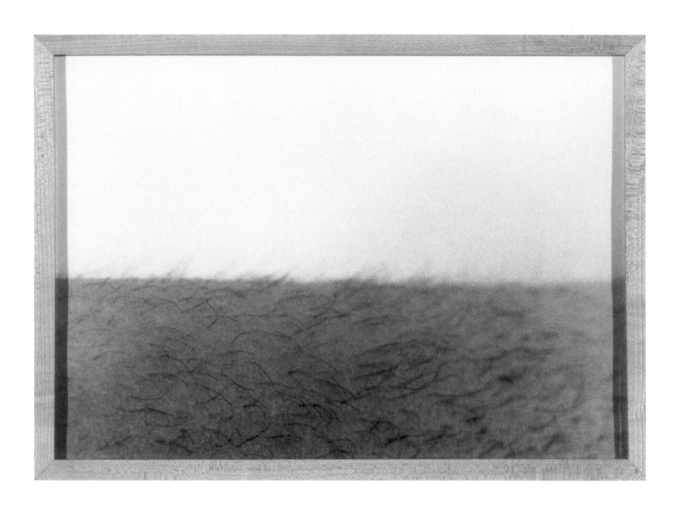

[1] *Untitled Landscape I* 1987 14 x 20 inches

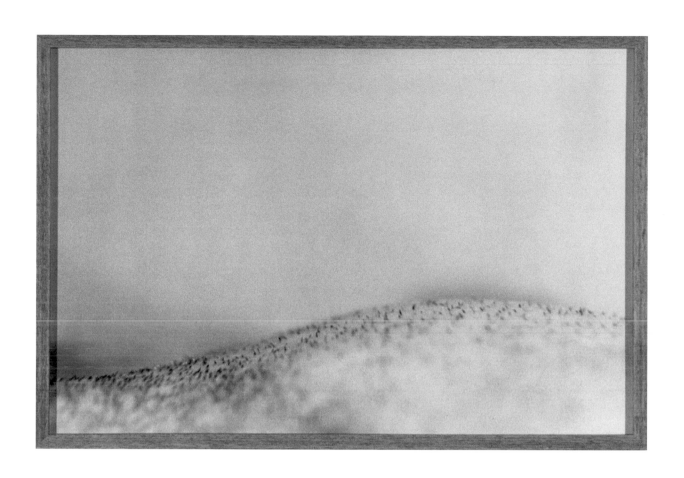

[2] *Untitled Landscape II* 1987 17 x 25 inches

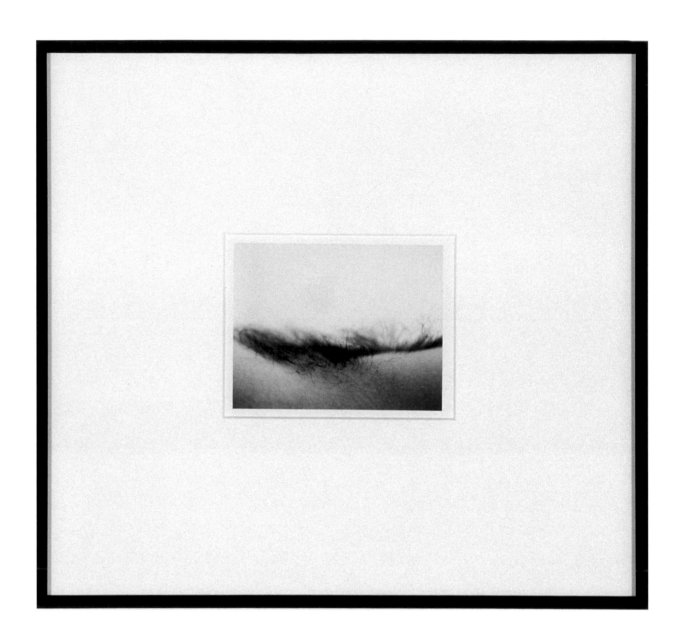

[3] *Study after "Untitled Landscape," 1987* 1987 12 x 13 inches

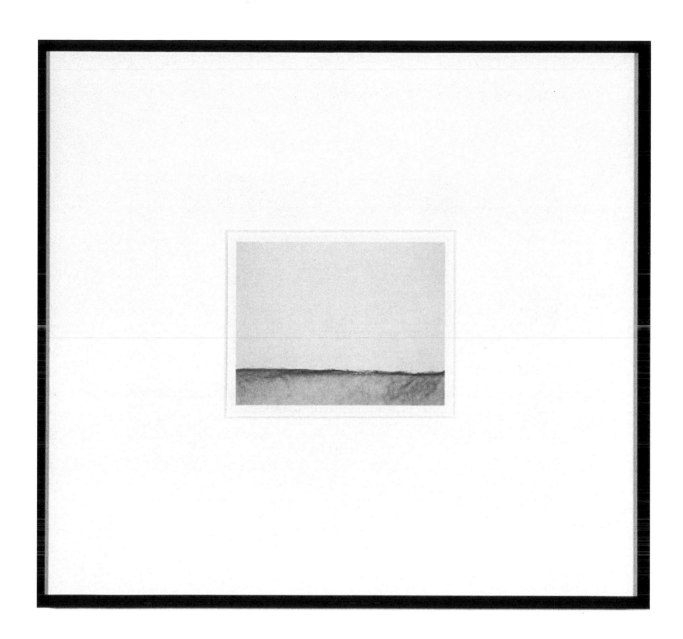

[4] *Study after "Untitled Landscape," 1987* 1987 12 x 13 inches

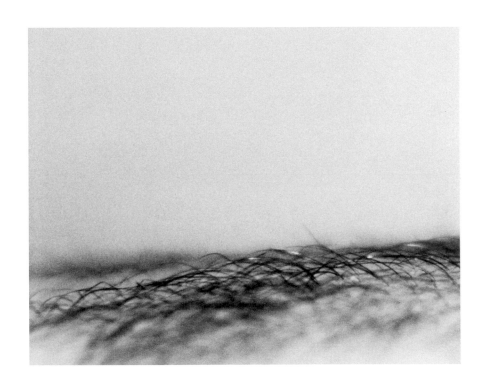

[5] *Study after "Untitled Landscape," 1987* 1987 12 x 13 inches (detail)

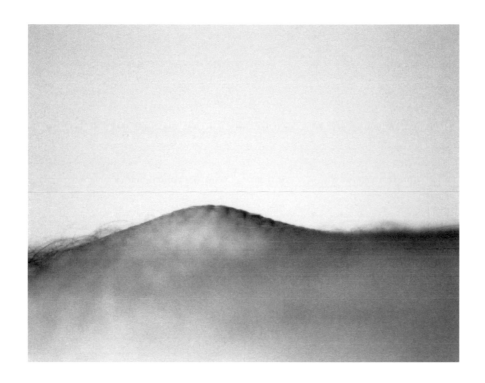

[6] *Study after "Untitled Landscape," 1987* 1988 12 x 13 inches (detail)

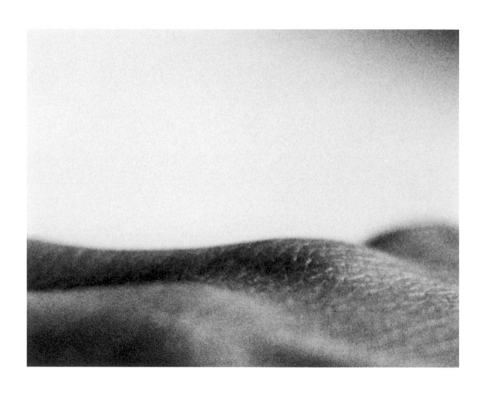

[7] *Study after "Untitled Landscape," 1987* 1990 12 x 13 inches (detail)

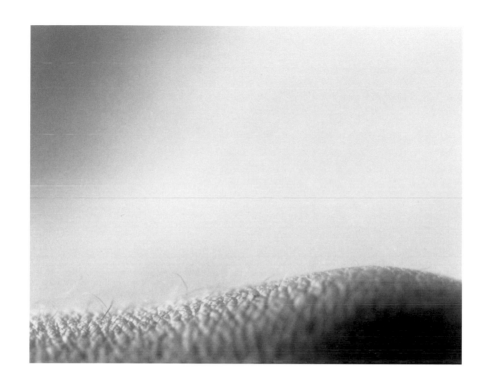

[8] *Study after "Untitled Landscape," 1987* 1994–95 12 x 13 inches (detail)

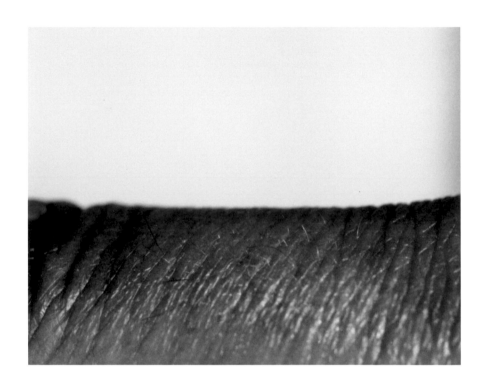

[9] *Study after "Untitled Landscape," 1987* 1996 12 ¾ x 13 ¾ inches (detail)

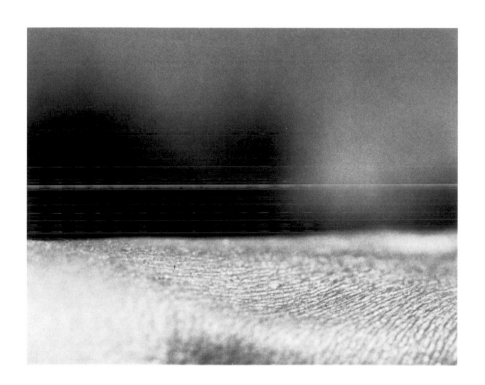

[10] *Study after "Untitled Landscape," 1987* 1996 12 ¾ x 13 ¾ inches (detail)

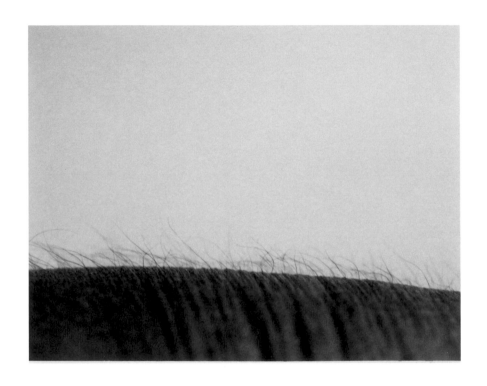

[11] *Study after "Untitled Landscape," 1987* 1996 12 ¾ x 13 ¾ inches (detail)

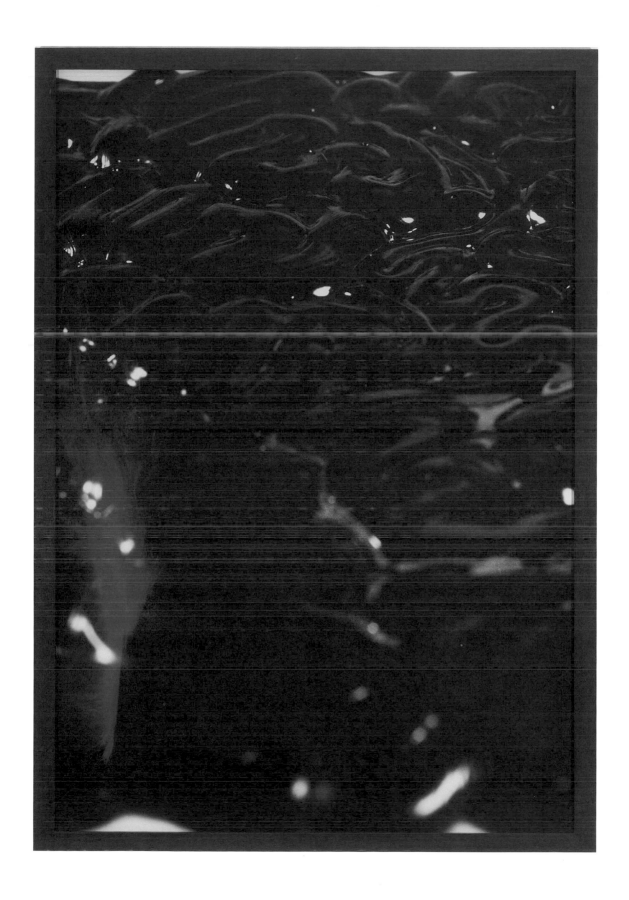

[12] *The Brown* 1996 73 ½ x 51 ½ inches

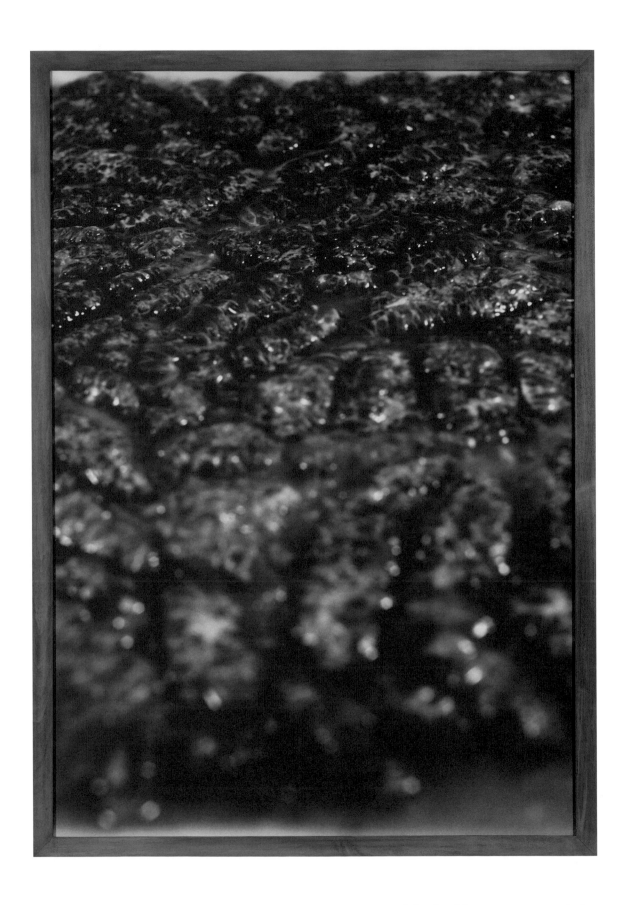

[13] *The Pink* 1996 73 ½ x 51 ½ inches

[14] *The Red* 1996 73 ½ x 51 ½ inches

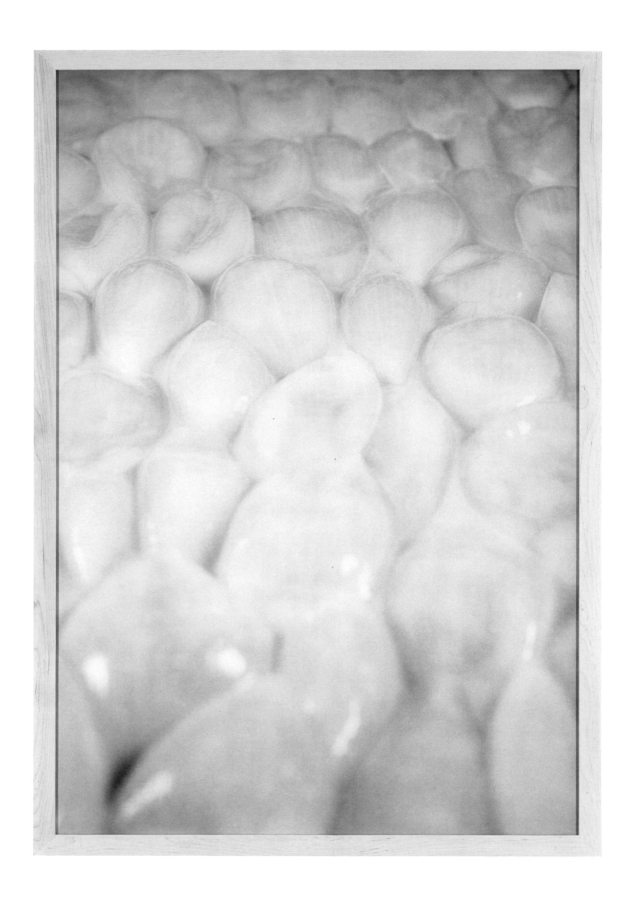

[15] *The White* 1996 73 ½ x 51 ½ inches

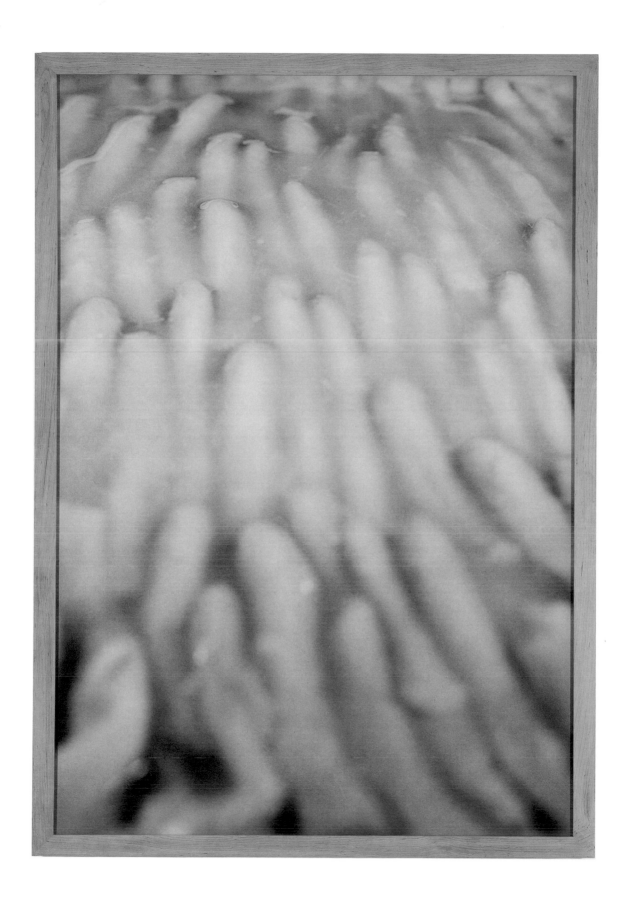

[16] *The Yellow* 1996 73 ½ x 51 ½ inches

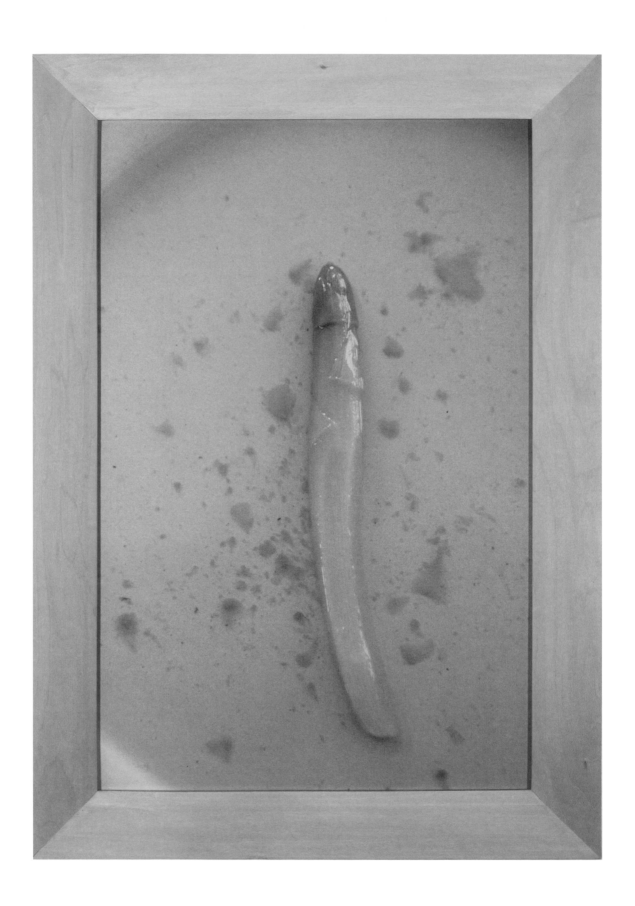

[17] *Sample* 1990 23 ½ x 16 ¾ inches

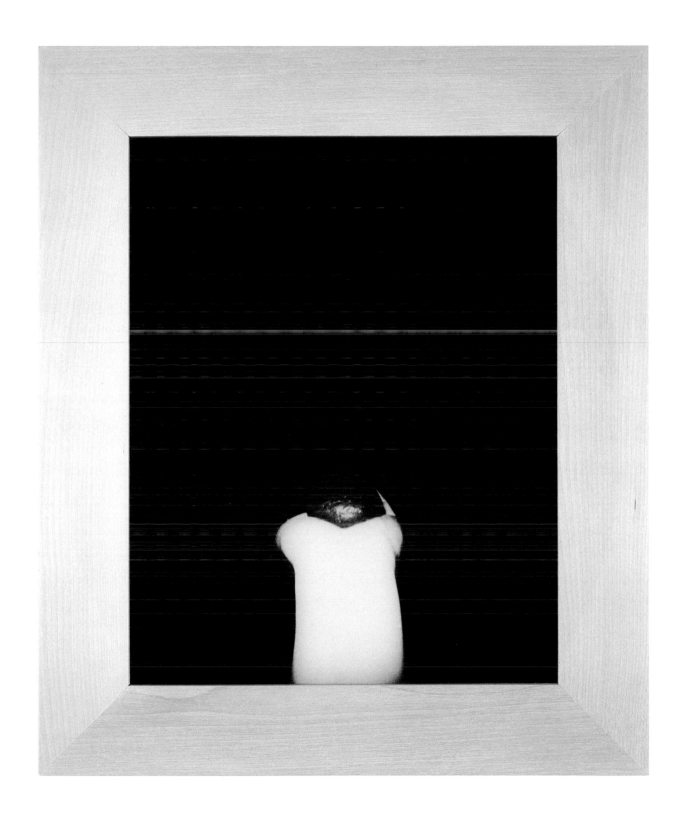

[18] *Sample 3* 1990 18 x 15 inches

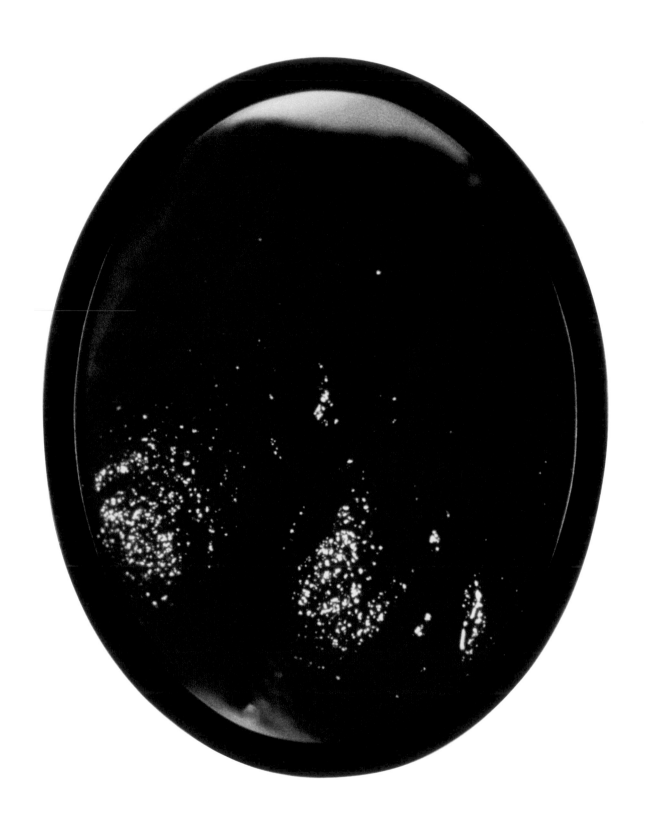

[19] *Detail 8* 1991 21 ½ x 17 inches

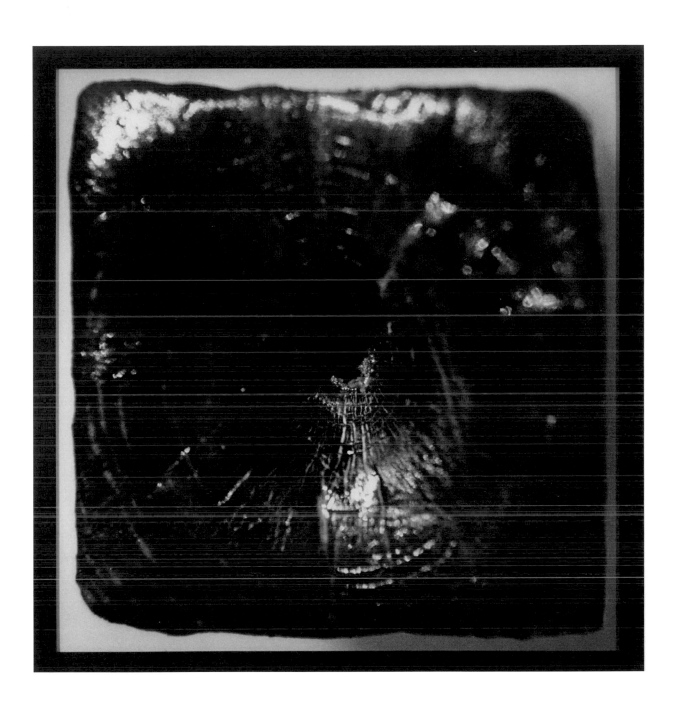

[22] *Untitled Hole* 1992 39 x 38 inches

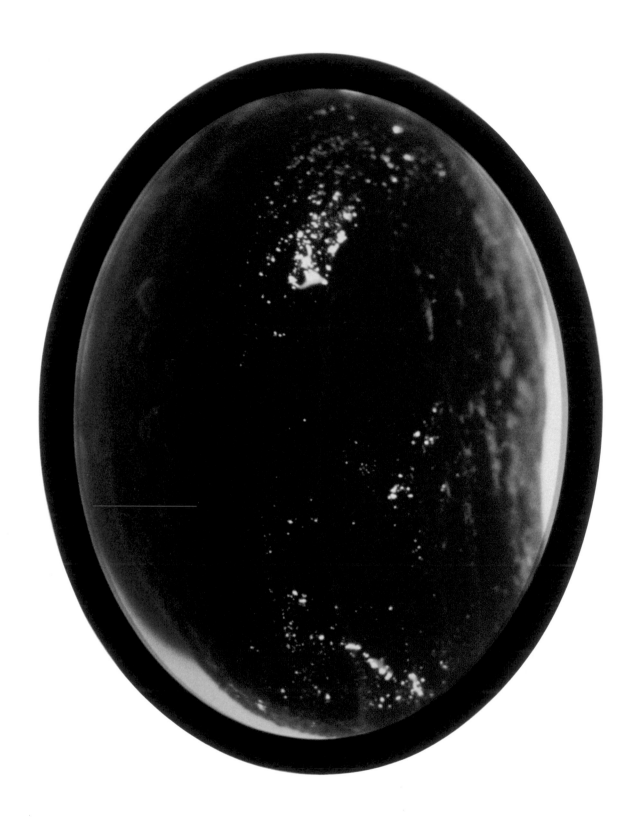

[20] *Detail 9* 1991 21 ½ x 17 inches

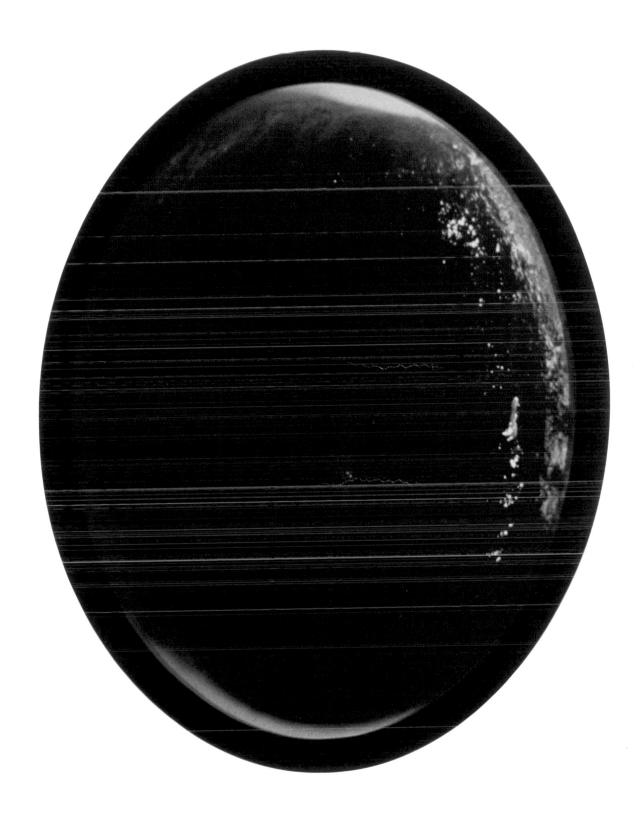

[21] *Detail 14* 1992 21 ½ x 17 inches

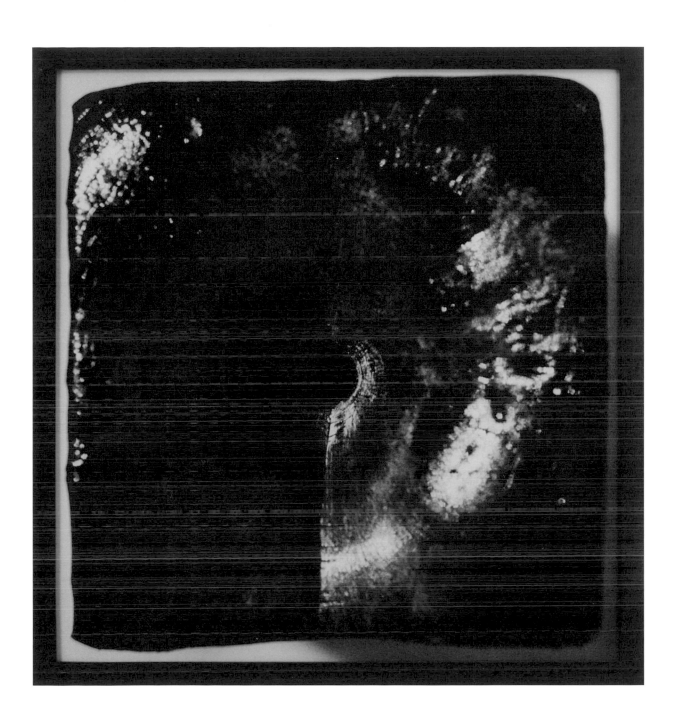

[23] *Untitled Hole* 1992 39 ½ x 38 inches

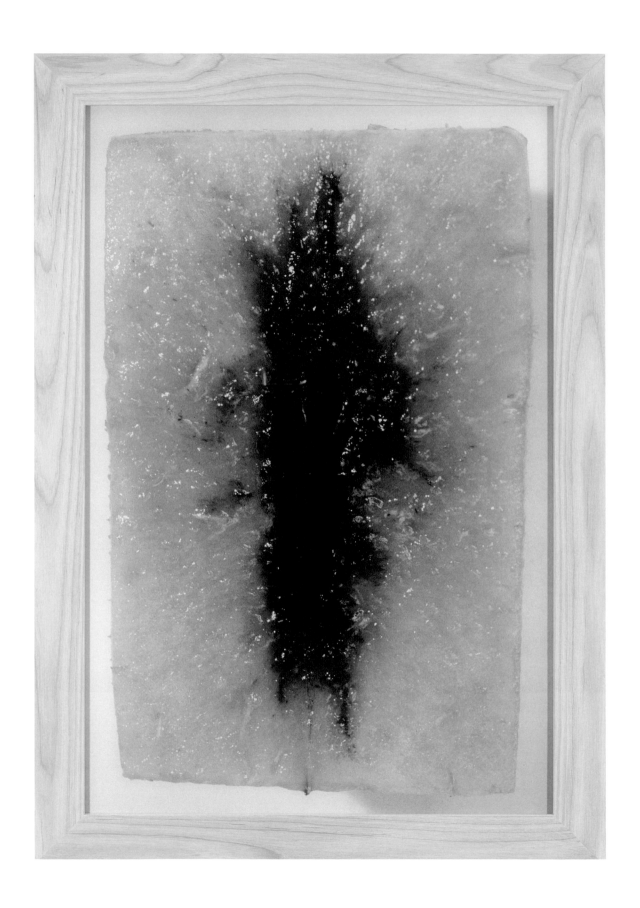

[24] *Untitled Part* 1993 33 x 23 ½ inches

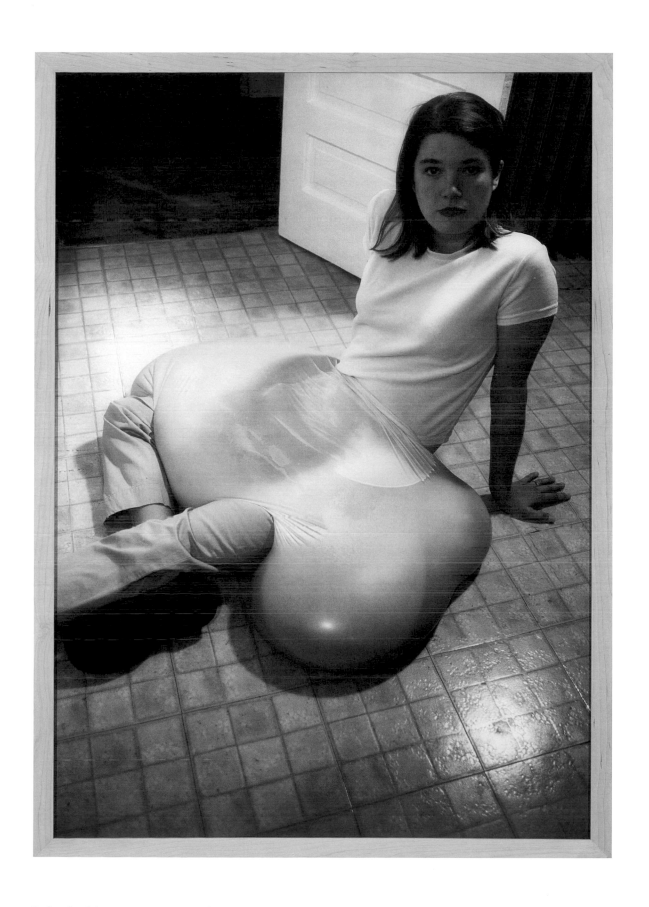

[25] *The Blob 1* 1999 52 x 37 ¼ inches

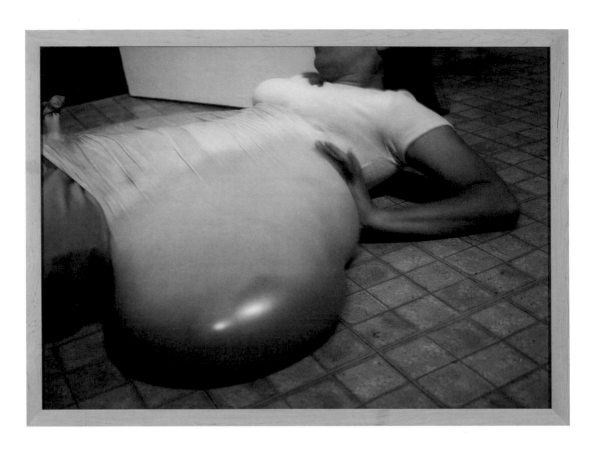

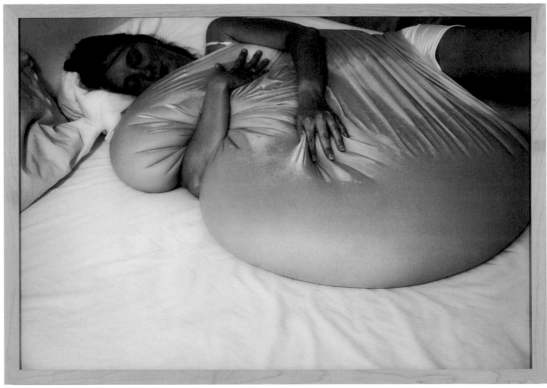

[26] *The Blob 2* 1999 30 ¼ x 41 ¼ inches
[27] *The Blob 3* 1999 34 ½ x 49 ½ inches

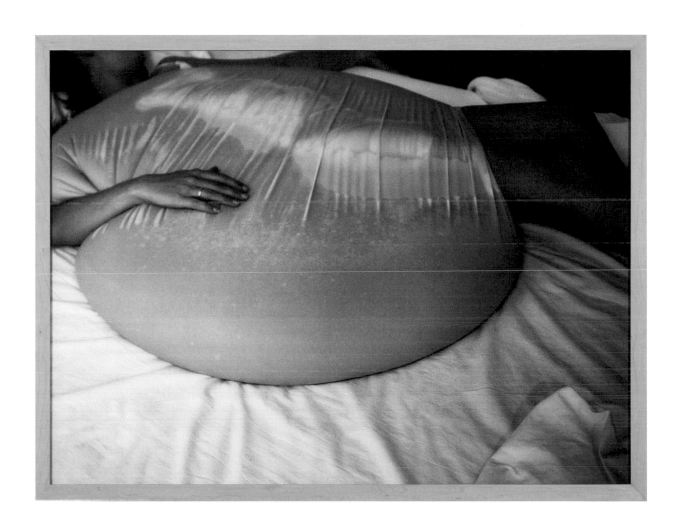

[28] *The Blob 4* 1999 37 x 48 ¾ inches

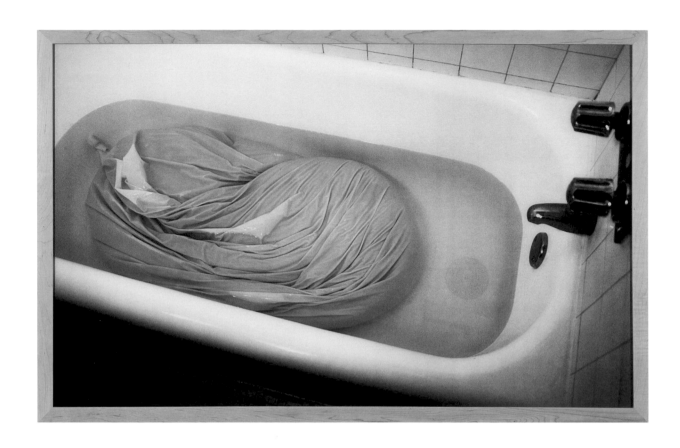

[29] *In the Bathtub 1* 1999 33 ½ x 52 ¼ inches

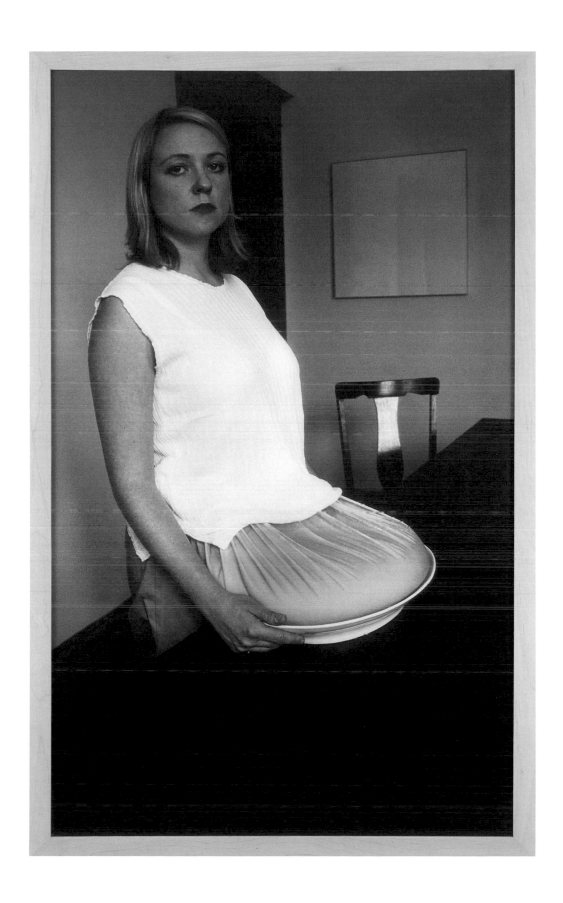

[30] *On a Platter* 1999 51 ¼ x 32 ¼ inches

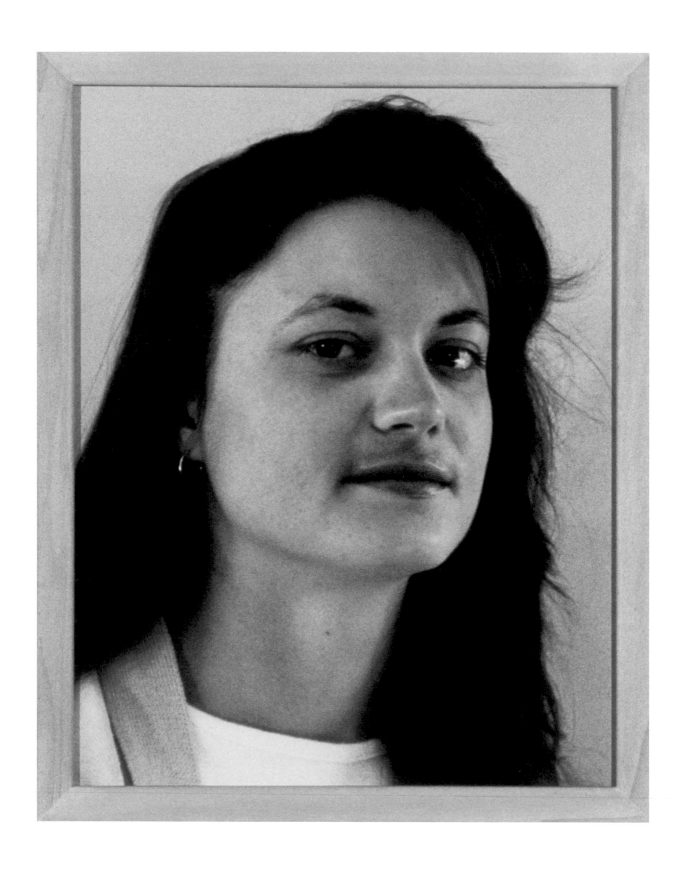

[31] *Untitled* 1988 15 x 12 inches

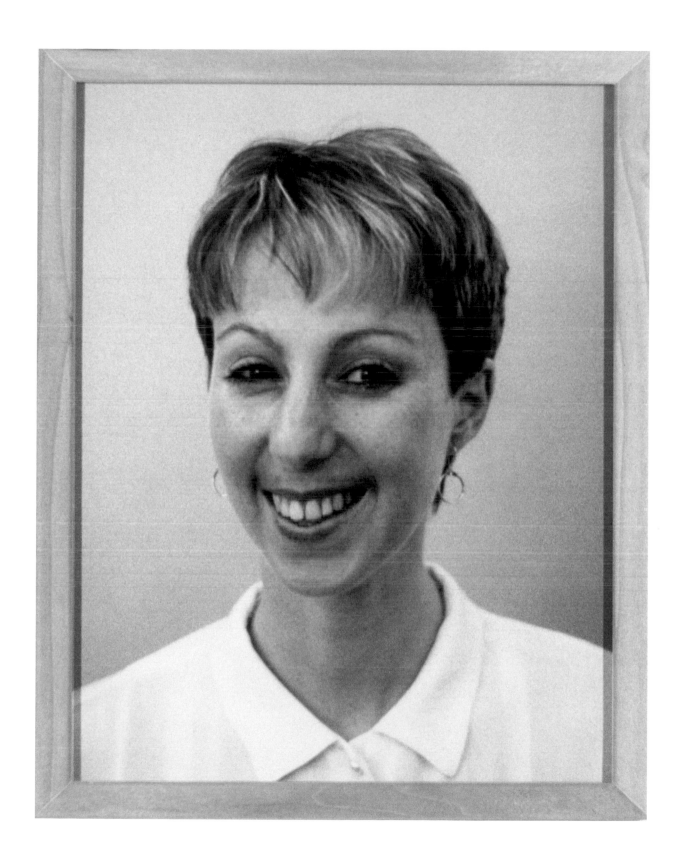

[32] *Untitled* 1988 15 x 12 inches

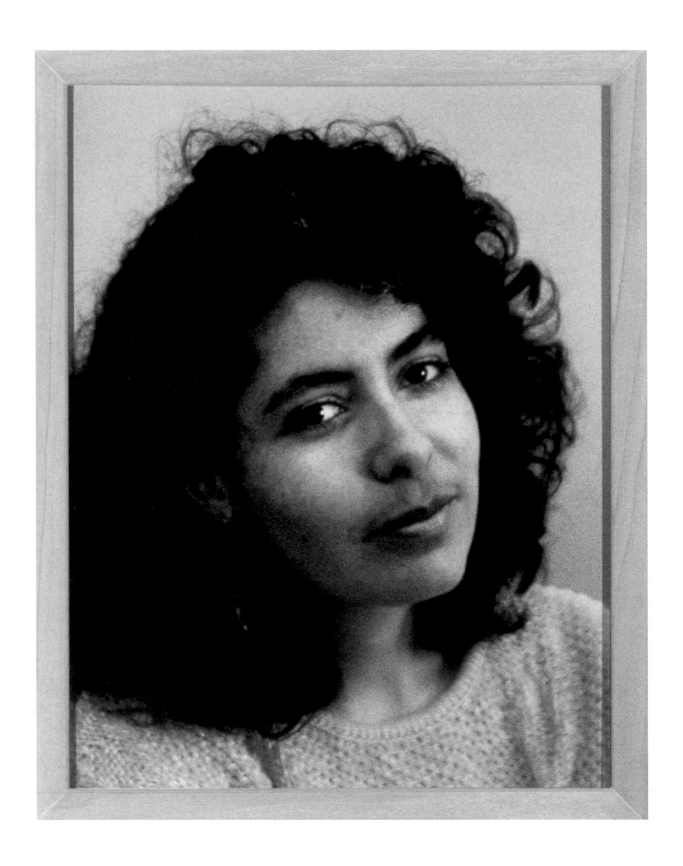

[33] *Untitled* 1988 15 x 12 inches

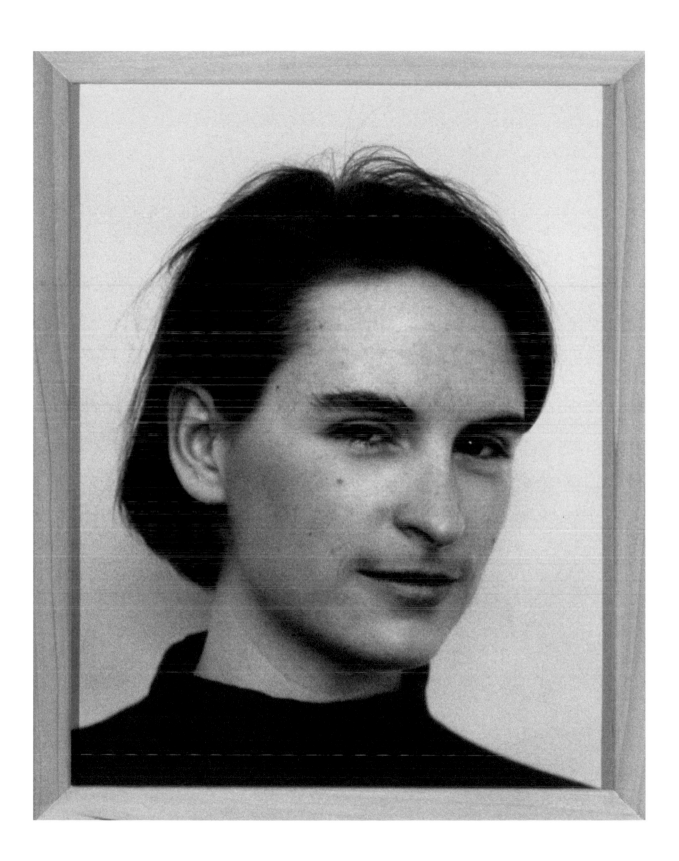

[34] *Untitled* 1988 15 x 12 inches

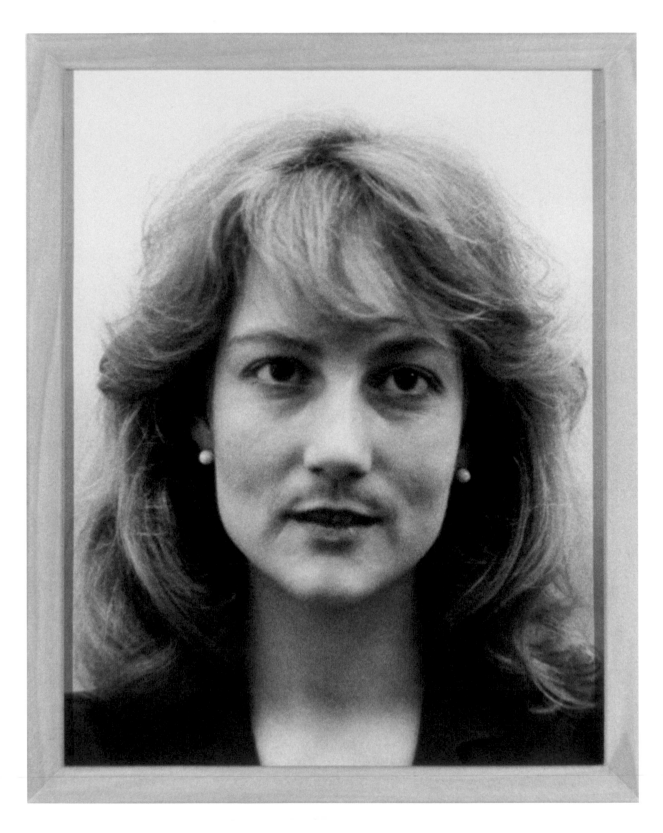

[35] *Untitled* 1988 15 x 12 inches

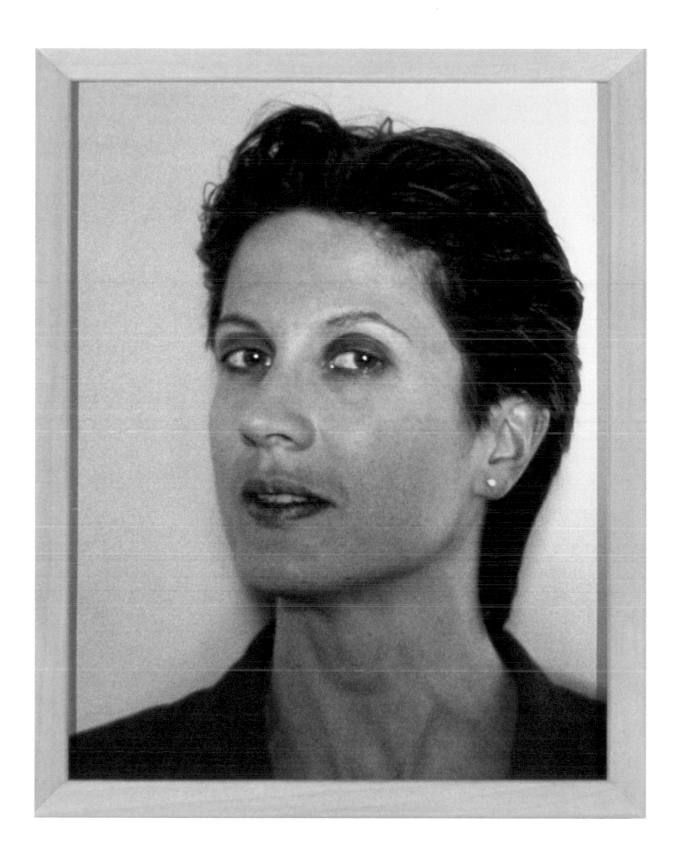

[36] *Untitled* 1988 15 x 12 inches

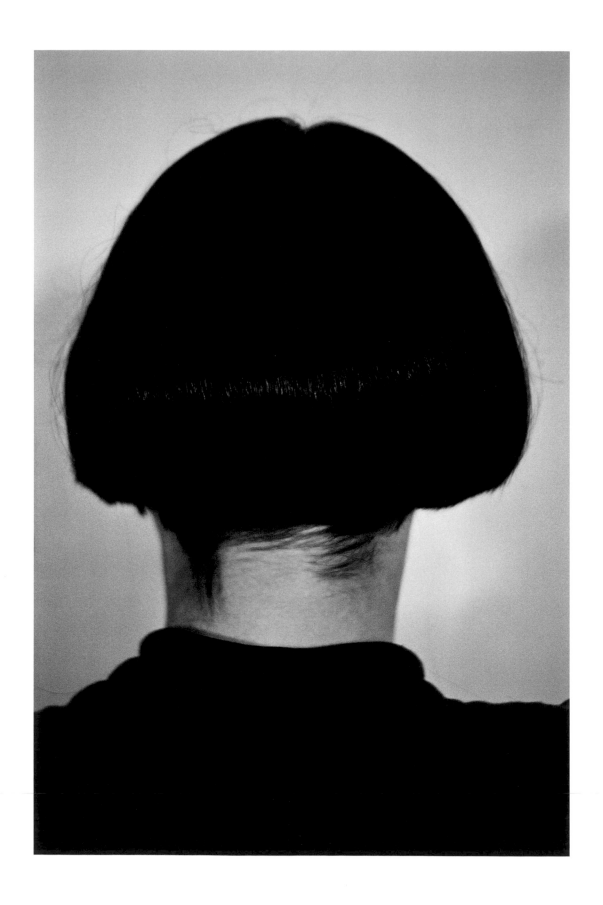

[37] *Head 2* 1989 28 ¼ x 19 inches

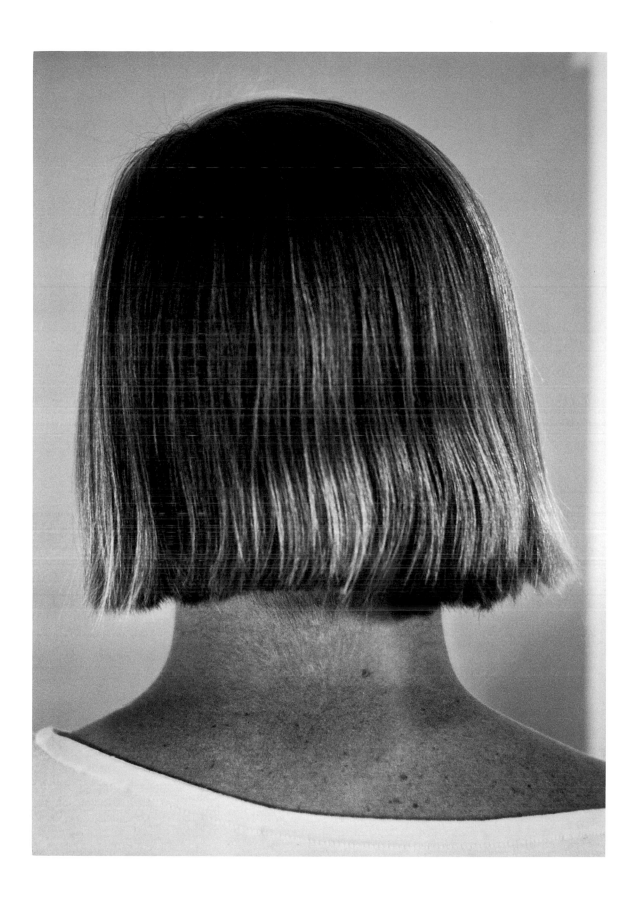

[38] *Head 3* 1989 26 x 18 ⅝ inches

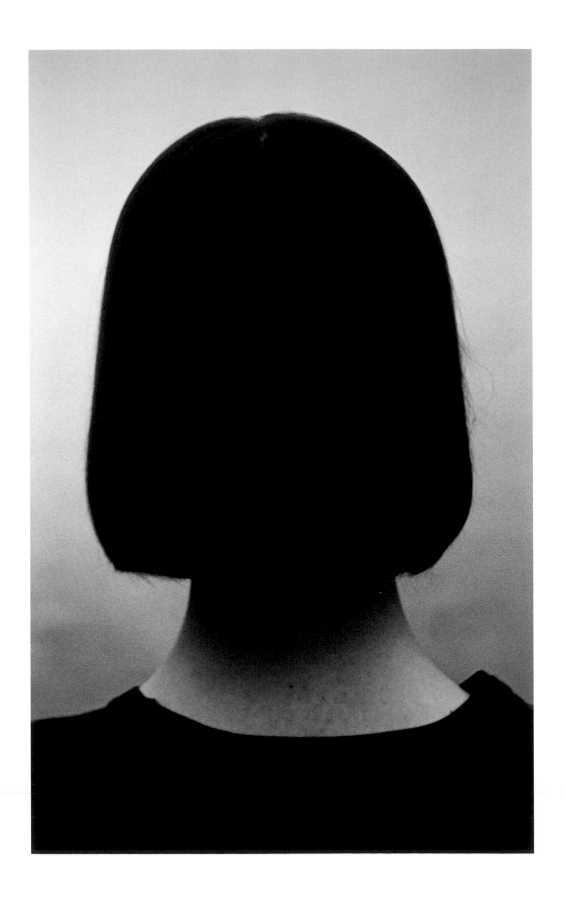

[39] *Head 6* 1989 30 x 19 inches

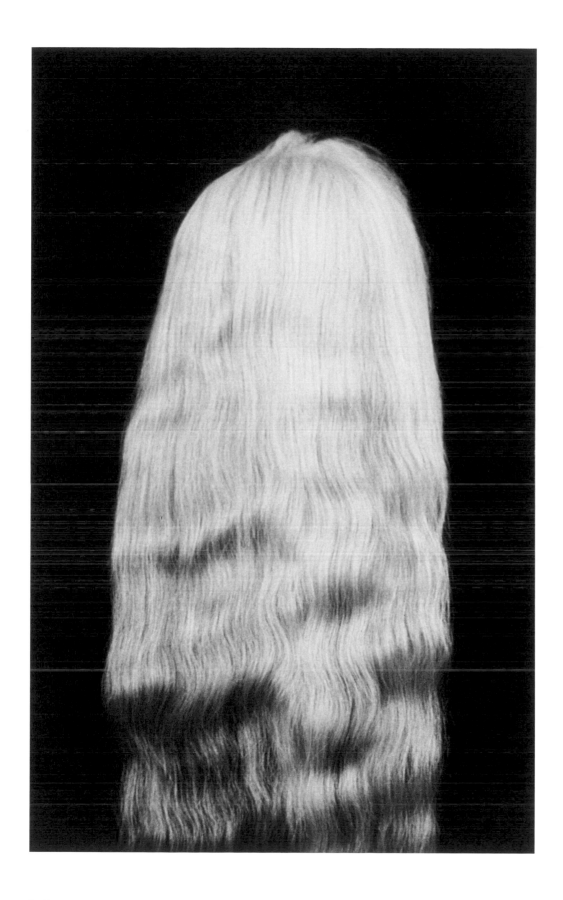

[40] *Head 8* 1990 30 x 19 inches

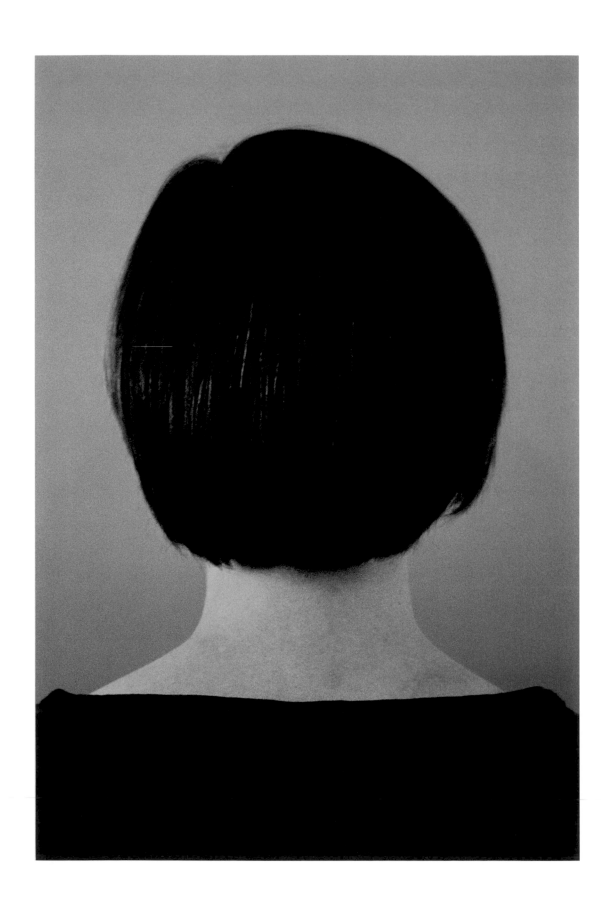

[41] *Head 10* 1990 26 ½ x 18 inches

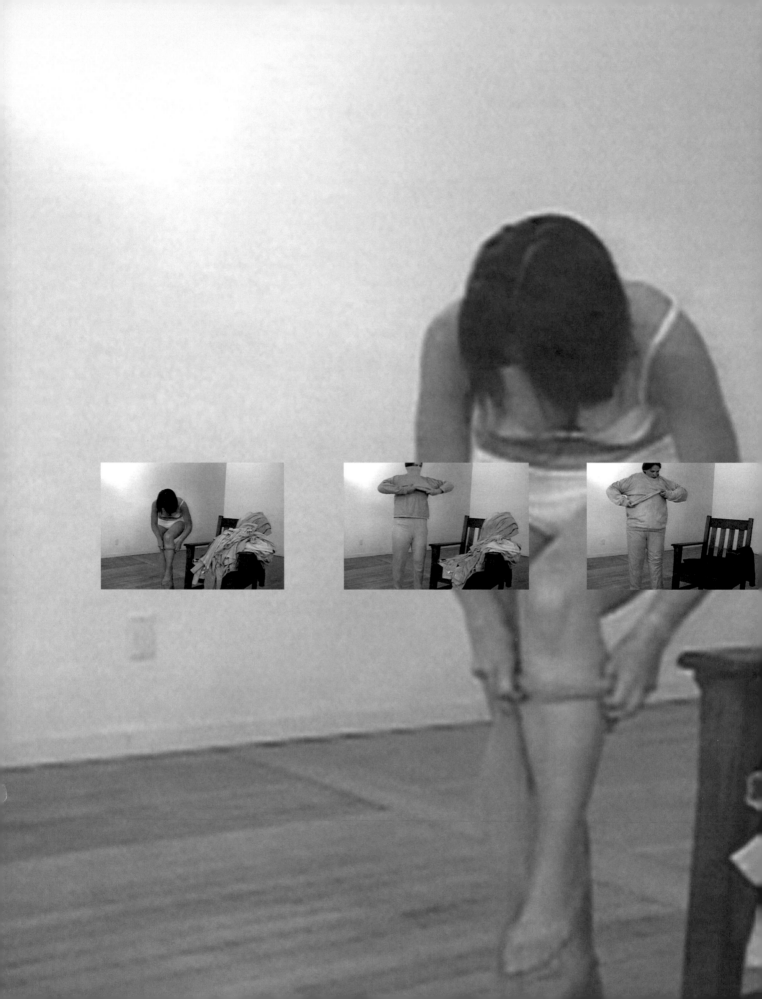

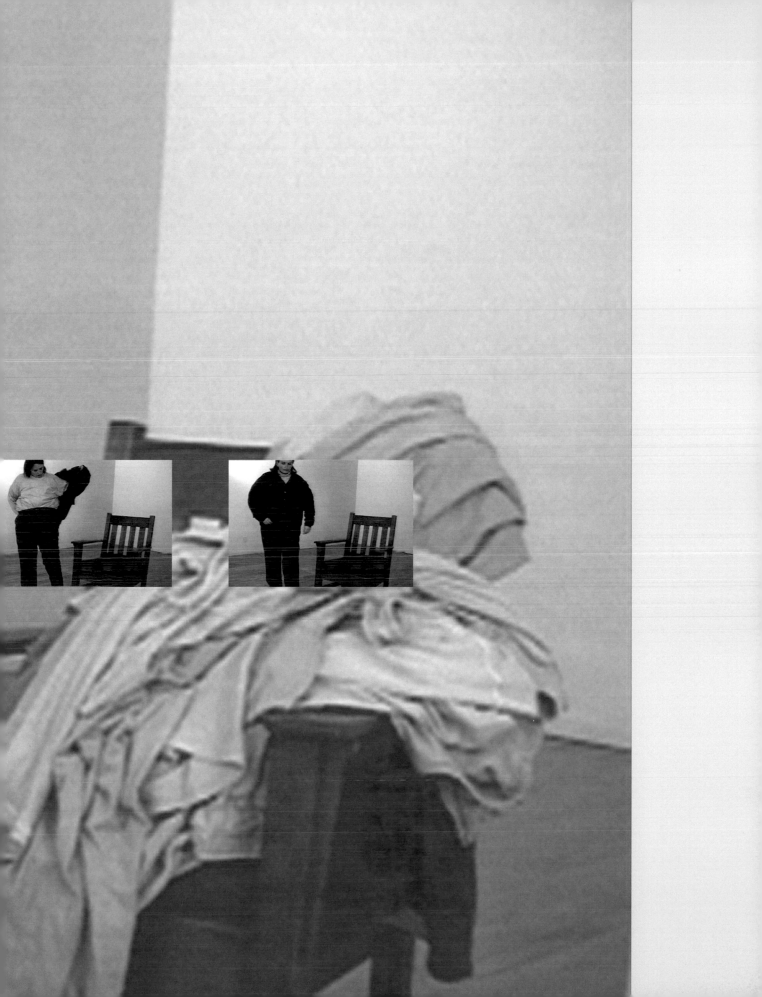

THE UNEXPECTED EFFECT

Heidi Zuckerman Jacobson

I was introduced to Jeanne Dunning's photographs in the early 1990s when I saw *Heads* [plates 37–41] exhibited in New York. Working on her Berkeley Art Museum exhibition more than ten years later, I was surprised to discover her *Untitled Landscapes* [plates 1, 2]. They were unfamiliar to me, although they in fact predate the *Head* works, but also familiar, as they clearly evoke earlier photographers and photographs. This confluence epitomizes an essential process in Dunning's work: subverting the recognizable and distorting the known. By thwarting expectations and confusing vision, Dunning's artistic practice offers the viewer opportunities for self-discovery as well as intellectual discovery.

Dunning is an internationally recognized artist whose work encompasses a variety of media, including photography, sculpture, and video. Born in Connecticut in 1960, since 1982 she has been based in Chicago, where she received her M.F.A. from the School of the Art Institute in 1985. A key figure in the Chicago art community since her 1987 exhibition at that city's Feature gallery, Dunning has been at the forefront of the Chicago-based neoconceptual movement, artists engaged with deconstructionist theory and critiquing the institutions associated with art. Dunning's unwavering focus as an artist has been the terrain of the human body. Questioning is central to her practice: perception, visual knowledge, the norms of gender and sexuality, and reality itself are all examined. From the beginning, her work gained notoriety for its provocative, and sometimes grotesque, depictions of the body.

By reenvisioning the relationship of the self to the body and the body to the world, Dunning has made significant contributions to contemporary visual culture. "Her images challenge the boundaries between inside and outside, normal and abnormal, what is taken in and what is

expelled, the erotic and the abject."[1] They have become a cornerstone of feminist art criticism. Following are some of the things that have been written about Dunning's work:

In describing the *Heads* (1989–90): "More subversively, through Dunning's particular choices of hair-shapes, her ambiguity added in through their 'monstrous' double-life-size scale, the compositional emphasis on the neck as a vulnerable shaft, and the vacuous, dream-like backgrounds of undifferentiated hues, they become the phallus."[2]

"By emphasizing the crucial details or aberrations, Dunning refuses to let viewers passively indulge in female beauty."[3]

Dunning's art, however, also speaks beyond the feminist perspective with which it is primarily associated. With the intention of rethinking the critical reception to date, the exhibition *Study after Untitled* proposes a new look at Dunning's oeuvre through the lens of art-historical influences and the genres of landscape, still life, and portraiture. Each formal category will include works from early in the artist's career juxtaposed with more recent works. The catalog essays open out the exhibition's perspective. Writer and curator Russell Ferguson discusses Dunning's production in relationship to painting, examining in particular the notion of tactility. Dunning's own essay reveals her work anew in the play of intention and hindsight. Together the exhibition and book reposition Dunning's work, broadening its associations beyond Chicago, the early 1990s, and feminism, to take a well-earned place in the larger canon of contemporary art history.

Study after Untitled, the exhibition title: the sequence of the phrase could be translated as "reference, reference, no reference." This rhythm is evocative of the reaction to a Dunning photograph—"Got it, got it, oops, not what I thought." The circular reasoning inherent in the title and the subsequent visual revelation defines Dunning's effect. In presenting unusual perspectives on familiar subjects, she reflects an ongoing investigation into the relationship between seeing and naming. The artist has said, "When people see [my images], at first they may not be quite sure what they're looking at. . . . One of my interests has been in provoking these misrecognitions, unbidden associations, and uncontrolled interpretations that can show us thoughts and interests we didn't know we had."[4] In *Study after Untitled,* viewers will be asked what they see, why they see, what they think, and what they know.

INFLUENCES ON JEANNE DUNNING'S WORK

The cited and confirmed influences on Dunning's work are formal—Man Ray, Edward Weston—or conceptual: Sherry Levine, Georgia O'Keefe, Carolee Schneemann, Cindy Sherman, Hannah Wilke.

Dunning, who did not specifically study photography, had an awareness of Weston's photographs due both to their ubiquity and to extensive coverage of the artist in *October* in the 1980s. Dunning and Weston share a formal affinity in the elegance of their black-and-white images, the purity of their compositions, and the use of titling to identify otherwise obscured subject matter. Each shoots in extreme close-up so that the object being photographed visually morphs into something else: body as landscape, vegetable or fruit as abstract study. Weston's iconic 1925 *Nude* [fig. 1] reveals the sleek lines of a female torso while simultaneously evoking

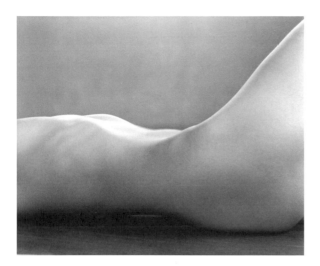

Fig. 1. Edward Weston: *Nude*, 1925

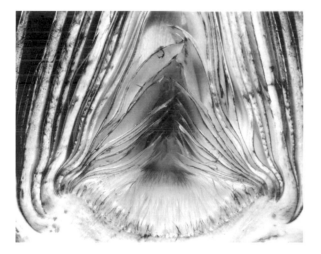

Fig. 2. Edward Weston: *Artichoke Halved*, 1930

a landscape. The curves of the body become undulating hills. Subtle, spare, and graceful, the image is reductive to a degree of perfection. His *Artichoke Halved* (1930) [fig. 2] precedes Dunning's "still life" images of plums, tomatoes, grapefruits, and nectarines. The detail communicates fragility while simultaneously distorting size. Weston's "portraits" of bell peppers, also from 1930, famously evoke the dramatic curves of the human form.

Dunning once described to me a particular Man Ray photograph she covets, an acute close-up of a person's neck and raised chin that metaphorically delineates the outline of a phallus. Surrealists treated the fragment apart from its original context and used fragmentation as a means to knowledge, discovering significance in the part that had been concealed in the whole. Like the Surrealists, Dunning uses photography to show that things are not as they appear.

Another artist who, like Dunning, was associated with the production of taboo images, Robert Mapplethorpe was creating his close-up photographs of the nude body at the time of Dunning's earliest works. Like much of Dunning's imagery, works such as *Livingston* (1988) [fig. 3] morph from direct bodily references to compositional studies of texture and form. The artists share a predilection for cropping and close-ups as well as the creation of stunning prints.

Georgia O'Keefe employed abstraction in her paintings as a way of "cloaking her imagery and insisting on its beauty."[5] Her locating of implicit sexual references in organic objects and her insistence on "showing" the female organs paved the way for Dunning. Similarly empowering was Carolee Schneeman's willingness to explicitly and uncompromisingly use her own body, internal and external, as well as her own emotions and desires, as subject matter. Dunning finds Hannah Wilke's late self-portrait photographs of her fight with cancer "astonishing." Here it is Wilke's willingness to display and expose herself—bald, bloated, fearful, and dying—again without apology, that Dunning admires.

Dunning's ability to use "photography to address issues of authorship, gender, and the workings of patriarchal society" owes much to Cindy Sherman and Sherry Levine.[6] Sherman's film stills are body-self explorations as well as investigations of traditional media images of women. Levine in her early black-and-white works appropriated art-historical images, including reshooting many images by Walker Evans. Dunning continues the evolution of photography as a conceptual medium and a feminist tool.

JEANNE DUNNING'S WORK

"Formally, Dunning's photographs are never ambiguous or obscure. They are solidly posed or composed, clearly lit, and perfectly focused. The pictures are the very model of photographic correctness."[7] In the space between this apparent correctness and her actual process, the intriguing ambiguity arises. In describing the way she devises images, Dunning explains that she sometimes takes a photograph with one thing in mind but gets something entirely different. Her practice can be seen as an antecedent as well as a mirror of the viewer's response, an unexpected effect.

"LANDSCAPE"

Dunning writes in her essay in this catalog that from early on, her images "managed to be multiple things at once, and not necessarily what we expected them to be." The titles of her works are intended to reinforce what people see; by calling these images landscapes, the artist is affirming the accuracy of the viewer's initial association. Additionally, she is implying that such a reference, even after one realizes that these are close-up images of a body, is in fact important to the overall understanding of the image. The duality matters. In this series as well as the others included in the exhibition, the artist refers to the genre without necessarily having to make work that is defined by or fits the genre.[8] Dunning creates landscapes from food as well as bodies, playing with the perception of organic substance as scenery. By distorting scale and perspective and emphasizing tactility, both series invite the viewer to reinterpret notions of landscape.

Each *Untitled Landscape* [plates 1–11] is a kind of snapshot—a unique photograph of a fragment of an unidentified body part. The first two were shot in color; all subsequent ones were black and white. For Dunning, these photographs conflate friends and family and a summer vacation: each transforms a section of the human body into a terrain, the skin surface presented as desert, field, sand dune. Epidermis and hair create unexpected horizon lines and give the image its extreme texture and tactility. The surface edge of the body becomes a field with unique subtleties: bulges form peaks, wrinkles are crevices, finer wrinkles make up fissures in the ground, and hair resembles plant life.

These intimate photographs can be likened to nineteenth-century land surveys investigating uncharted deserts and mountain ranges. An open sky occupying two-thirds of the image meets the horizon line of skin. Shadow and blur mimic the atmospheric effect of distance. The series also borrows from the aesthetic of photography's f64 club in looking at essentialized natural

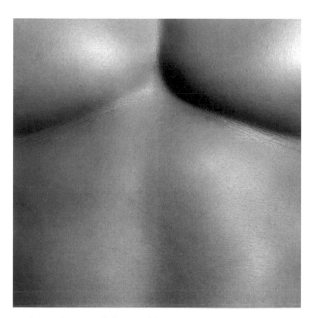

Fig. 3. Robert Mapplethorpe: *Livingston,* 1988

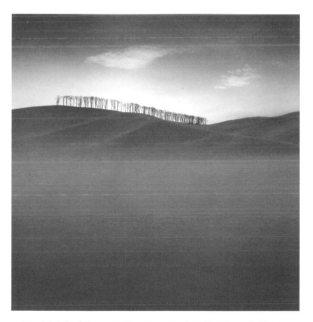

Fig. 4. Michael Kenna: *Hilltop Trees, Study 2, Teshikaga, Hokkaido, Japan, 2004,* 2004

forms abstracted into shapes. The nod here to traditional landscape photography can be discerned next to an image such as Michael Kenna's *Hilltop Trees, Study 2, Teshikaga, Hokkaido, Japan, 2004* (2004) [fig. 4], a sepia-toned gelatin silver print that eerily evokes Dunning's *Untitled Landscapes.*

In *The Red, The White, The Pink, The Yellow,* and *The Brown* (all 1996) [plates 12–16], the artist uses comestibles (beets, onions) to create "fields" of color and texture that suggest internal (bodily) landscapes. The varied, gelatinous surfaces extend into an infinite expanse. While the perspective is not directly overhead, the view shares with aerial photography the quality of transforming topographical features into rivulet patterns stretching over a distance. The foods become swamplands unified by a dominant color. For example, *The Pink* suggests various organic forms—a tongue, fruit, bacteria magnified—as well as abstract monochromatic painting comparable to that of color field painters who created "overwhelming, wall-size fields of stark, vibrant, pure, in-your-face color so powerful as to hurt one's eyes at close range."[9] Dunning's monochromes serve to highlight what is us and what is not us, what is within and without, and suggest that any clear distinction is lost. The raked angle and immense size engulf the viewer. The artist implies that what you may lose yourself in is—you.

"STILL LIFE"

What is a still life, and how can a piece of fruit or a body plus a blob be characterized as such? Like the majority of Dunning's work, this section of the exhibition is ripe with humorous plays on traditional associations.

In *Untitled Hole* (1992) [plates 22, 23] and *Untitled Part* (1993) [plate 24], Dunning abstracts the top of a plum and the inside of a nectarine into networks of lines and planes of color. Close cropping highlights these deconstructed elements, with the result that things appear, at least initially, to be other

than what they are (they appear to be sexual organs). Things are read independent of their source. If still life specializes in the motionless aspect of nature, here nature is not imitated, but examined, and exploited, for its appearances and characteristics. In *Sample 3* (1990) [plate 18], peeled red tomatoes are held up in the palm of a hand. The gesture references one traditional purpose of still life paintings, displaying gifts of foodstuffs. However, the black background eliminates any context or point of interest beyond the red form and the palm with bended wrist in which it is held.

The *Hole* works pose questions about what we reveal and what we keep hidden. Dunning concentrates on holes that resemble orifices of the human body. The response to these "still life" works is visceral first and theoretical later. There is ambiguity regarding both how the image works and what it is. In *Hand Hole* (1994) [fig. 5], Dunning fixates on a detail that can change something (a hand) from mundane to menacing. Because that thing is revealed to be not what was initially thought, the viewer grants himself or herself permission to look longer and more closely.

In traditional still life painting, the arrangement of inanimate objects is usually placed on a table. Dunning uses the table and dining plate in contextualizing the items arranged on them. In *On a Platter* (1999) [plate 30], a woman stands by a table. Her "blob"—a fluid-filled sac the color of her flesh—spills over into a platter, serving up this part of her body for study. Her blob can also be read as a dose of reality, as if to say, "These are all of the things that I no longer choose to hide."

In *The Blob 3* and *The Blob 4* (both 1999) [plates 27, 28], a woman lies motionless on top of a white bedsheet. In both photographs, her hands rest gently on the protruding sac that encapsulates her torso. In the former, she sleeps contentedly, holding herself like a body pillow. This form is connected to her body, yet she holds it, suggesting that she and the blob are separate objects arranged on the bed. The woman in *The Blob 1* (1999) [plate 25] sits on a linoleum floor, casually leaning back on her hands. She confronts the viewer with her gaze as a blob form hangs out from her hips; it is part of her, not a separate object. It can be seen as a comforting as well as a smothering presence.[10] Leslie Camhi wrote, "That dear old blob is an allegory for our uncertain corporeal limits—those points where the body bleeds over into psychological territory."[11]

Dunning's images communicate the sensuous appeal of texture—the wet tomato, the palm that evokes an orifice, the pliable body sac. Dunning has said, "I see my work as taking these things that seem familiar and comfortable and normal and just tweaking them a little and giving them a little push so that suddenly you see that, wait, they aren't so familiar and normal. . . . It's about noticing those places which I think are revealing of all those places that we are in discomfort or are in denial [about]. . . . So it really does just come from life."[12] Still life: unmoving, frozen, misidentified, projected upon, and yet, still, life; nothing other than life itself.

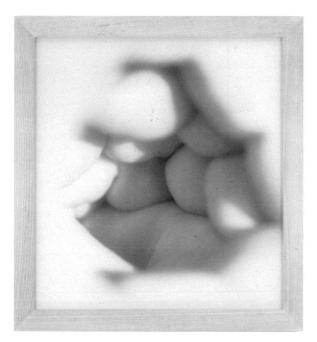

Fig. 5. *Hand Hole,* 1994

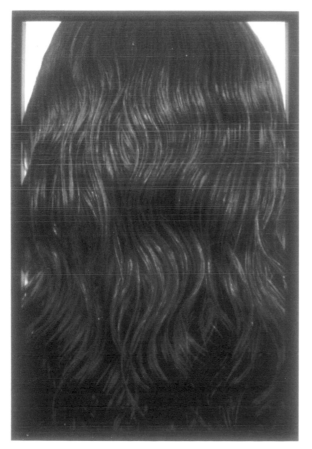

Fig. 6. *Red Detail,* 1990

"PORTRAITURE"

"Dunning's work thoughtfully scrambles our conventions of portraiture, replacing a coherent image of the body with a version that reflects our far less tidy internal experience. Haunting, grotesque, obscene and fabulous, her work transforms anatomical aesthetics into compelling science fiction."[13]

In the *Heads* (1989–90) [plates 37–41], Dunning explores notions of female beauty and physical identity. These are formal portraits of the backs of women's heads. She emphasizes hair as a primary individuating factor among the women; the main distinction between the repeating poses is the color and length of each individual's bobbed hair. *Red Detail* (1990) [fig. 6], by contrast, focuses on the color of the wet long hair, the body all but disappearing from view. The *Heads* are about withholding information, and about the conventions that viewers bring to looking at images. As these are portraits that do not reveal a face, they refute the gaze of the viewer and ironically become increasingly fetishized. The artist suggests that keeping something hidden holds the attention longer.

The women in the headshots in the *Untitled* works from 1988 [plates 31–36] look ahead, smiling. They are photographed as they might be in a professional studio portrait or passport photo, from the shoulders up. Upon closer observation, however, the viewer realizes that the subjects have faint yet unmistakable mustaches. In these photographs, Dunning is blurring boundaries between things that are assumed to be diametrically opposed, such as men and women. The series includes a self-portrait.

In the videos *Extra Skin (Adding)* and *Extra Skin (Subtracting)* (both 1999) [plates 42, 43], the female subject, the artist and a model, respectively, examines her body through the addition of layers of nude clothing or the apparent peeling of layers of her skin, conveying the social pressure to obscure flaws and display physical assets. In *Extra Skin (Adding),* the viewer witnesses her slow transformation from

naked skin and distinct (female) body parts to a
nearly uniform (sexless) round shape. *Trying to
See Myself* (1999) [plate 44] is a performative work
with an endurance element. It references early
video work by artists such as Bruce Nauman and
Vito Acconci and is also a "frustrated exercise in
self-study, exploring the impossibility of getting
an undistorted view of your self."[14]

In both *Untitled* and *Extra Skin (Adding)*, the
artist has manipulated the visual representation of
secondary sex characteristics, such as body hair and
the curves of a woman's breasts and hips, to challenge
the viewer's perceptions of femininity. They are
portraits of a gender as well as, if not more than,
any individual.

JEANNE DUNNING: INFLUENCE AND CONFLUENCE

While it is very difficult to pinpoint the effects of
one artist on others, it is indisputable that Dunning's
influence is vast and varied. Although significantly
older than Dunning, John Coplans, a noted curator,
critic, and teacher, began his photographic career
at age sixty in 1984, approximately the same time
as Dunning. His production focused on nude self-
portraits. He explored his own flesh in all its gnarly
minutiae by concentrating on small part after small
part of his body. Parallel to the *Untitled Landscape*
photographs, Coplans worked in black and white.
His primarily large-scale format is comparable to
that of Dunning's largest works.

In 1997, Emiko Kasahara, who was born in
Tokyo in 1963 and currently lives and works in
New York, created a series of digital photographs
of women's cervixes [fig. 7]. These large-scale
(approximately 50 x 60 inches) color images are
very pink. The center of each features a hole, and
all include a luminous, reflective area. The photo-
graphs are ostensibly abstract and their subject
is not identified. Visually, Kasahara's images are
comparable to those of Dunning in that each artist
presents, in sumptuous color and on a large scale,

Fig. 7. Emiko Kasahara: *Pink (#1)*, 1997

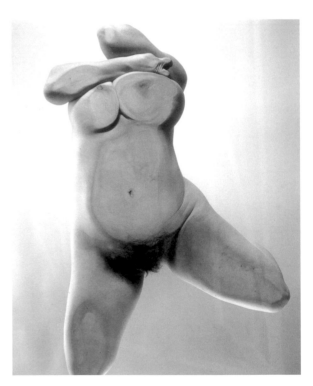

Fig. 8. Jenny Saville and Glen Luchford: *Closed Contact #10*, 1995–96

Fig. 9. Pinar Yolacan: *Untitled,* 2002

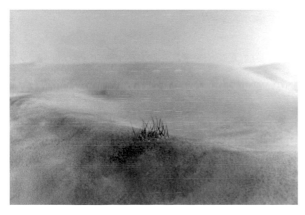

Fig. 10. Allan deSouza: *Terrain #5,* 1999

objects photographed so close up that their identities are concealed. Kasahara, however, presents the insides of actual bodies instead of their clever impersonators.

Jenny Saville, known primarily for her large-scale paintings of her zaftig nude body, has done a series of photographs in which, by collaborating with Glen Luchford, she presses parts of her naked body onto sheets of glass and photographs them from below [fig. 8]. Definitive outlines and contours are destroyed and a mutable image that overspills the frame is produced. Her body becomes an assortment of abstracted masses for the most part unrecognizable as flesh. Instead, they appear to be broad planes of color with areas of light and shadow. Like many of Dunning's works, these self-portraits confuse traditional genre ascriptions.

Pinar Yolacan, a twenty-three-year-old Brooklyn-based artist, created a series of portrait photographs, titled *Perishables* [fig. 9], in which her sitters wear garments made of tripe, chicken skin, and other meats. The reference to Dunning's *Blob* works—in which a woman dressed in a bloated flesh-colored sac simulates the intimacy and repulsiveness of the human body—was cited in *The New York Times.*[15]

In a series titled *Terrain* (1999) [fig. 10], Allan deSouza created C-prints of bodily detritus such as hair, eyelashes, earwax, and fingernails, intending to reclaim the landscape as a personal thing. He wrote, "The *Terrain* series consists of fabricated, table-top landscape models that have then been photographed. . . . They resite landscape as a national(ist) projection of the racialized, gendered body, partly by their fabrication."[16] DeSouza expands upon Dunning's use of photography as a means of addressing social and political concerns centered on the human body.

As a precursor to relational aesthetics, in which artists make work that the viewer eats, reads, or paints to finish, Dunning's images are fulfilled in the minds of her viewers. The work requires the external gaze

for comprehension and completion, for closure. Acknowledging the unexpected effect of her images on the viewer—embarrassment, surprise, relief—Dunning states that her work "makes you question yourself about why you are reacting that way."[17] Such essential questions about perception and self-awareness encourage additional ones, including "Who am I?" and "Who are you?" Her work pokes at the line between what we think we know and what ultimately lies beyond our control.[18] Dunning's interest lies in the connection, or lack thereof, between knowledge and expectation. She asks questions, viewers answer them, and ask more, and in this process things are seen, named, renamed, and rediscovered. Study after untitled, another unexpected effect.

1 Alla Efimova, Berkeley Art Museum, May 2002.

2 Kathryn Hixson, "Double Reverse Flip: Jeanne Dunning's Photographic Ambiguities," *Arts Magazine,* December 1991, 42–45.

3 Museum of Modern Art, New York, "New Photography 14," 1998, http://www.moma.org/exhibitions/1998/newphoto14/jeanne_dunning.html.

4 Jeanne Dunning, "Introduction," in Jeanne Dunning et al., *Show and Tell* (Chicago: self-published, 2001), 8.

5 Emily Hall, "Female Flesh: Our Bodies, Our Selves, Our Blobs," *thestranger.com,* October 12–18, 2000, http://www.thestranger.com/2000-10-12/art2.html.

6 Amada Cruz, "Jeanne Dunning," Museum of Contemporary Art, Chicago, 1994, brochure, 5.

7 Keith Seward, "Jeanne Dunning," *Artforum,* January 1995, 85–86.

8 It is to acknowledge this play on types that the genre-based categories that serve as divisions in the exhibition as well as the catalog have quotation marks around them. Dunning's works are both landscape and not landscape, still life and not still life.

9 Jim Lane, "Color Field Painting," 31 July 1988, http://humanitiesweb.org/human.php?s=g&p=a&a=i&ID=247.

10 Hall, "Female Flesh."

11 Leslie Camhi, "Return of the Blob, The Body Oozes Out of Bounds," *The Village Voice,* February 15, 2000, 69.

12 Anna Weaver, "Jeanne Dunning, Art Theory Dep. Chair: A Day in the Life," *Northwestern Chronicle,* October 17, 2002, 2.

13 Ralph Rugoff, "'Dumb' and Down Under: A Report from the Sydney Biennale," *LA Weekly,* August 16–22, 1996, 43–44.

14 Bodybuilder & Sportsman Gallery, "Recent Photographs and Video Works by Jeanne Dunning," October 2001, http://www.bodybuilderandsportsman.com/public-html/press/dunning.html.

15 Cathy Horyn, "A Shelf Life So Short It Takes the Breath Away," *The New York Times,* November 16, 2004, A24.

16 Allan deSouza, "Contemporary Art and Identity: South Asian Diaspora in North America," Baum Gallery of Fine Art, University of Central Arkansas, 2000, http://www.asianart.com/exhibitions/diaspora/desouza.html.

17 Weaver, "Jeanne Dunning."

18 Feigen Contemporary, "Jeanne Dunning," http://www.feigencontemporary.com/index.php?mode=artists&object_id=30&show=home.

THOUGHTS FOR *STUDY AFTER UNTITLED*

Jeanne Dunning

Untitled Landscape I (1987) [plate 1] is the first piece I ever made that pictured the body. When I took this picture of the hairs on my (unshaved) leg, I was just fooling around, trying to use up a roll of film, but when the slides came back from the photo lab I saw that the leg had become a landscape. From the very beginning, things in my work didn't sit quietly where they were put. Instead, they managed to be multiple things at once, and not necessarily what we expected them to be. *Untitled Landscape II* (1987) [plate 2] is a photograph of a man's shaved cheek, and here again what seems most apparent is something I wasn't thinking about when I took the picture. Although I didn't consciously plan it, the pairing of a woman's unshaved leg with a man's shaved cheek seems positively freighted with the weight of our cultural and gendered expectations regarding our bodies, which is exactly the territory of all my work to follow. The *Untitled Landscapes* developed out of a play between what I thought I was taking a picture of and how I saw the picture after the fact. My thoughts on my work reflect a similar combination of intention and hindsight—how I thought about the work when I made it, informed by what I have learned from reactions to it since.

Most of my work uses simple gestures to try to get at complicated relationships and reactions. Like their color precursors, the black-and-white landscapes [plates 3–11] manipulate your impulse to identify what you're looking at by giving you a horizon line. As landscapes, these places might be atmospheric and romantic; they are vistas seen from far away, perhaps at a stretch evoking quintessential examples of the Kantian sublime. But once you realize it's a body, this distance instantly collapses. Suddenly what you're looking at is only inches away from your face and edging towards being a little too close for comfort, given that you don't know what part of the body it is, or whose body it is, or even if it's the body of a man or a

woman. We don't see bodies in this kind of proximity unless they are our own or those of our lovers or children. The movement from landscape to body collapses response as well as distance. It heightens your awareness of the disparity between how you feel about what you're seeing as a landscape and how you feel about it as a body.

My early work often self-consciously adopted a conventional format; in the pictures of women with mustaches (1988) [plates 31–36], it's that of the clichéd studio portrait. I meant these pieces to have the banal feel of high school yearbook photos or mantelpiece portraits, and this gives the viewer certain expectations that the pieces overturn. When confronted with just one of these pictures, sometimes people perform a mental editing operation, eliding the mustache. After all, when we see a woman with a mustache, isn't it polite to pretend it isn't there? But when confronted with the group, the viewer must realize that the mustaches are the point of the pictures, that what you are supposed to see is exactly the thing that the culture has taught you to pretend does not exist. These mustaches look quite realistic, and on a certain level the work is asking a very naive question: How did we decide that the ability to grow a mustache distinguishes men from women, since women have mustaches too? My work refuses to believe in the distinctions posed by categories like male and female, normal and abnormal, attractive and repulsive, or that which we are and are not allowed to acknowledge.

The mustaches are fake; I used makeup to put on the kind of thing it usually hides. It seemed important that these should be constructed mustaches—constructed, just as gender differences are. I wanted the donning of the mustache to seem like a purposeful act: of (minor) transgression, of usurpation, of belligerence and refusal in the face of the absurdity of being told that if you have a mustache you are not a woman. At the same time, it's a childishly irreverent gesture, to draw a mustache where it doesn't belong. My models and I may be serious about our small transgression but we also give a nod towards its ridiculous side as we participate in a particular kind of schoolboy joke.

Gender-bending played a big role in my early work, although not always in overt form. The *Heads* (1989–90) [plates 37–41] quietly take issue with gender by playing both sides of the divide, being both feminine and phallic, classically iconic and highly fetishized, seductive and withholding. Some people have seen the *Heads* as acting out a gesture of refusal: women turning their backs on the objectifying gaze. But that's too simple: look at what happens when these women turn their backs—they are fetishized and objectified even more than if they faced the camera, because we can't see their faces, because the focus is on the hair and the neck (classic fetishes), because of the sometimes ineluctably phallic silhouette. Attempting to escape objectification makes its hold on us all the more claustrophobic.

It took me a while to realize that part of what the *Heads* were about was power dynamics— the power of withholding information. These images are in the format of portraits, and the first thing we expect to see when looking at an image of someone's head and shoulders is her face. By not giving us the very first thing we expect from them, the works may frustrate our initial expectations and desires. But they also may hold our attention a little bit longer because they don't immediately satisfy us, don't tell us everything we want to know. Can not speaking sometimes be a way to keep people listening?

I try to provoke a visceral reaction with my work. I want you to stand in front of the work and, before you have time to think of anything else, feel a bodily correspondence with what you are looking at. I want the push-pull of simultaneous identification or attraction and repulsion. Like the *Heads,* the images of fruits and vegetables from the early nineties use seductive surface and color to draw you in. For most viewers, these images immediately bring to mind internal organs and bodily orifices, and once in a while a hint of the scatological. The associations range from the taboo through the disgusting to the horrific, while remaining (sometimes uncomfortably) fascinating. But what these images actually picture is disarmingly mundane; what could be more wholesome than fruits and vegetables? Precisely because they are not what we thought they might be, we can give ourselves permission to look, not only at the image but also at how we felt when we mistakenly thought it was something else. Sometimes people find these images obscene. If they are obscene, how much of the responsibility for their obscenity lies with us and our own interpretation of what we are looking at, since it's really just a picture of a tomato or a plum after all?

The Red, The White, The Pink, The Yellow, and *The Brown* (all 1996) [plates 12–16] are named after the colors they depict, treating the color as a noun rather than an adjective, as though it were an object. The pictures themselves are not of objects but of undefined materials that seem to flow beyond the frame. It's difficult even to categorize these viscous substances as liquid or solid, let alone identify them. Like so much of the work that precedes them, these works are all about boundary issues, this time focusing on the boundaries of the body and the self. We all have a great investment in the idea that we know where our borders are—like everyone else, I go about my everyday life feeling confident that I know where my body ends and the rest of the world begins, that it's clear what is part of me and what is not part of me, and that the division between the two is stable. Yet this clearly is not the case. Things cross that line all the time. When we eat, we take in things that were not part of us, and they become part of us; we regularly lose our hair and our fingernails; our skin is permeable to air and water. There is constant exchange between what's me and what's not me, between the inside and the outside. I wanted to visually evoke the loss of this boundary; in a way, I was trying to turn the body inside out and let the inside engulf the outside. The colors and textures allude to things that either cross the border between the inside and the outside of the body, or are usually safely contained on the inside. Yet the pictures hint that these flowing, messy substances might begin to envelop you, rather than you safely containing them.

While I always intended the "colors" photographs to be able to stand alone, they were conceived as part of a video installation. The video, titled *Within/Without* (1996), depicts a baby just at the stage of learning to eat solid food. It is made up of many short clips only a few seconds in length. We see the spoon lifting the baby food to her mouth—amorphous colored mush reminiscent of the stuff pictured in the photographs, which is in fact also all food. The baby food goes in, the baby spits it out, the little spoon scoops it off her chin and maneuvers it into her mouth again, only to have it spit out again, *ad infinitum . . . ad nauseam.* The constant crossing of the food between inside and outside eventually suggests a blurring of the distinction between the two. It is thought that infants do not understand their bodies as self-contained

and that we must learn that there is a difference between ourselves and the rest of the world. *Within/Without* imagines this as a messy process, as the baby manages to get far more food on her face than into her stomach.

In order to explore the question of how we construct and maintain our sense of self, I need to use things we can see, so I use the body to talk about the self. But whatever is literally, physically going on in my work can usually also be understood as a psychological metaphor. The loss of physical borders alluded to in the "colors" photographs can also suggest a loss of psychological borders. I wanted these images to evoke a melting of the distinction between self and other, container and contained, inside and outside.

The "blob" photographs (1999) [plates 25–30] began with the idea of the blob itself. I was trying to conceive of a body reduced to pure physicality, to corporeality without form, to weight and mass and nothing else. I imagined this thing I called a blob as a body with nothing to give it structure or definition, no individuating characteristics, no self inside. In the first pictures I took of the blob, it was sitting on one end of a couch. It lay there like an inert, lumpish puddle, and the pictures were boring. I realized that there had to be a physical interaction with this body-as-object in order to bring it to life. The pictures needed to foreground our relationship to the blob, not its simple existence.

If you could remove your self from your physicality and confront your own body as a pure corporeality, what would you see, and how would you feel about it? Would you recognize it as yourself? Would you embrace it as a necessary (if perhaps abject) aspect of who you are, and might you then feel a kind of affection for it? Acceptance? A desire to reincorporate it? Would it be familiar in spite of its weirdness? Or would it be foreign to you, would you push it away, reject it? Or would you simply acquiesce to its weight? Could you have a relationship with it as your own uncanny twin? This is what I wanted the pictures to explore.

The blobs leave one part of the body recognizably intact. This is the skin, necessary to hold together the amorphous mass inside. The skin is also the surface of the body, the part we see—but of course we all know that appearances are deceiving. *Trying to See Myself* (1999) [plate 44] takes multiple vantage points, none of which are especially successful in letting me see myself. From the point of view of my own eyes, I can only take in a distorted, fragmented view of my lower half. The mirror image and the video itself may show me a whole of sorts but it's a mediated whole. The nylons, excruciatingly sloughed off at the end of the tape, become an indexical mold bearing the misshapen imprint of the negative space of the lower half of my body. Like the shed skin of a snake, the nylons hold a hollow memory of my presence. When you finally get to see yourself, are you always already empty or gone?

Trying to understand our relationship with skin as the boundary of the body led to *Extra Skin (Adding)* and *Extra Skin (Subtracting)* (both 1999) [plates 42, 43]. *Adding* imagines the skin as a welcome, necessary buffer protecting us from the world, one which we might even want to bolster with new layers in order to make ourselves safer. *Subtracting* sees the skin as a barrier that keeps us from making contact and connecting with things outside of us, and so tries to peel it away.

My early work starts with the body as misrecognized. Our bodies would seem to be quint-essentially familiar, yet the simplicity with which misrecognition is created shows the body to

be unfamiliar and foreign. Trying to understand our relationship to our bodies led me to look at our relationship to our sense of self. It seems to me that it's not difficult for us to understand ourselves as subjects; we each experience ourself as a thinking, feeling "I," interacting with but distinct from the world. Equally, we all know that we are objects in that our bodies are physical—we take up space and obey the laws of gravity like everything else. The difficulty comes in reconciling the two and understanding how we are both subjects and objects at the same time. My work is not about the problem of the mind/body divide, but rather about the problem of their coincidence.

SKIN AND SURFACE

Russell Ferguson

In what follows I intend to trace a strand that runs through Jeanne Dunning's work from the beginning: its relationship to painting, and the way that continuing fascination intertwines itself with Dunning's ongoing interest in the body.

An early work such as *Untitled Landscape I* (1987) [plate 1] is a good place to start. A close look at the picture reveals that it shows part of a human body, although—characteristically— exactly which part of the body remains highly ambiguous. (For a long time I believed it was an arm, although I now know it is actually Dunning's own leg.) The realization that we are looking at (part of) a body, however, comes only after we have experienced the image in another way. The composition is designed to evoke a landscape. The horizontal format, apparently showing a large, pale sky above and a varied topography in the lower third, is a compositional structure carried over into photography from eighteenth- and nineteenth-century landscape painting. The fact that—prompted by pictorial convention—we are quick to read hairs and flesh as vegetation and hillside is a testament to the continuing force of such conventions. And the opposite approach is also possible. In a famous essay, Maurice Merleau-Ponty wrote that Cézanne depicted "the structure of the landscape as an emerging organism."[1] The ambiguity relates not only to the body, but also to the history of picture making. We see images the way we have *learned* to see them, and we read Dunning's image as a landscape long before the title gives us some dubious confirmation of that reading.

In a series of black-and-white "studies after" *Untitled Landscape* [plates 3–11], Dunning presses the ambiguity through references to the highly pictorial tradition of photography, perhaps best exemplified by the work of Edward Weston, which itself took its compositional vocabulary directly from painting, despite its renunciation of both large scale and color. Like

Dunning, Weston was drawn to the conflation of the human body with the forms of shells, fruit, sand dunes, and so on.

The fact that we *can* in the end recognize the leg as a leg, or at least as part of a human body, is just as integral to the work as the initial impression of a landscape. The conventional pictorial structure is put in place only to set this fundamental uncertainty creeping up on the viewer. And the uncertainty itself remains uncertain; this is not a simple trick that is over once the mystery is revealed. The gender of the body, for example, never does become clear. As Dunning has said of these pictures, "You can't tell who it is or whether it is a man or a woman or what part of the body you're seeing—and there it is an inch from your face. Generally you're not that close to anyone else's body for very long unless you're having sex, which can make the image slightly disconcerting." [2]

Beyond the question of gender confusion, Dunning's invocation of sexual activity opens up another aspect of her work: it repeatedly shows us things that are incredibly soft, even squishy. Her photographs often suggest a process of melting that borders on dissolution. *The Edible 1* (1997) [fig. 11] shows skin covered in pudding. The appeal to pleasure is inescapable, and almost intoxicating. The pleasure, of course, lies in the transfer of the infantile substance—vanilla pudding—to the adjacent flesh, which is quickly subsumed into the overall rubric of "the edible." The hairless body under the pudding suggests a female subject, but the scenario being played out remains highly ambiguous. No real information is given that could situate these works in the context of any substantial narrative. If it is a sexual act, who is involved? Is anyone in control? As Dunning said in connection with a related body of work made at the same time, the *Puddle* pieces, "this work is about the idea of being overwhelmed by and enveloped in something, of completely losing yourself in something. But the twist in that for me is the hint that maybe what envelops you might come from you. Maybe you're losing yourself in yourself." [3] This inward-looking, even solipsistic, account of the work defeats the search for implied narrative by reminding the viewer that the image consists of precisely two things—skin and pudding, the pudding over the skin—and nothing more. Everything else is what we bring to it.

Beyond the implied pleasure—both infantilizing and sexualized—of the gooey pudding spread over the willing body, we can, I think, also situate *The Edible 1* in another context of pleasure: the pleasure of paint and painting. When Dunning says that the work is about "completely losing yourself in something," she echoes Harold Rosenberg's description of forties and fifties Action Painting: "The American vanguard artist took to the white expanse of the canvas as Melville's Ishmael took to the sea." And equally, when Dunning suggests that "maybe you're losing yourself in yourself," we can think of Rosenberg's proposition that "art as action rests on the enormous assumption that the artist accepts as real only what he is in the process of creating." [4]

In other, slightly earlier, works by Dunning—*The Red, The White, The Pink, The Yellow, The Brown* (all 1996) [plates 12–16]—gooey foodstuffs are characterized not by their taste, but by their color. This choice, I think, makes the relationship with painting—and indeed with paint itself—inescapable. There is a clear reference to Barnett Newman's series of paintings *Who's Afraid of Red, Yellow, and Blue* (1966–70), for example, although where Newman usually

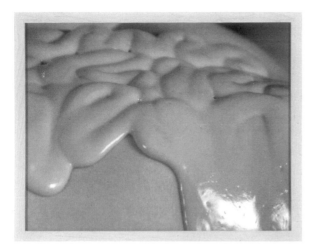

Fig. 11. *The Edible 1*, 1997

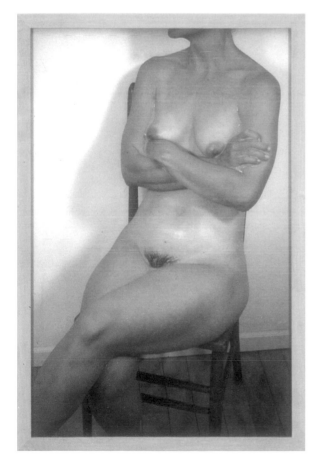

Fig. 12. *Untitled with Food*, 1996

stakes out the unequivocality of the primary colors, Dunning is equally happy with secondary colors such as pink or brown, feminine or excremental, colors that are—conventionally, at least—inappropriate for an exalted absolute.

Dunning is after something different. Her work, as she says in her essay in this catalog, treats color "as a noun rather than an adjective." It refers to the substance more than to the hue. A hundred years ago Kandinsky could ascribe emotional and spiritual values to particular colors.[5] This is not Dunning's approach. She is interested less in color than in paint: paint that can be squeezed from its tubes into dense mounds of color, the surface characteristic converted into a thoroughly three-dimensional presence that can be touched and manipulated. The relationship between color and paint is implicitly compared to that between skin and the body's internal organs. Color, like skin, is conventionally thought of as a Platonically two-dimensional surface, without depth. Paint, like a glistening kidney, is stubbornly insistent on its slimy three-dimensionality. This is actually something that Newman knew too. He did not always restrict himself to the primary colors. And here and there on his monochrome surfaces there are occasional drips of paint that the artist chose to leave. As his widow recalled, "Barney used to call them 'tears.'"[6]

The Edible 1 takes a step back from the explicitly paintlike references of *The Red, The White, The Pink, The Yellow,* and *The Brown,* but the allusion to paint is by no means left behind. The creamy pudding is pure pigment as well as pure food. This vision of paint as lush and buttery is quite different from the relatively dry, chalky feel sought after by many painters today. The paint that Dunning alludes to is the paint of expressionism: thick and excessive. This is color that would taste good.

The conflation of pigment and nutrition is equally present in *Untitled with Food* (1996) [fig. 12], in which a woman sits naked, arms folded, apparently unconcerned that all the cracks and crevices of her

body are filled in by a viscous substance. Hollis Clayson has called this "the spectacle of the body breaking down, of a worrisome even repugnant permeability of the skin, of the rupture of the epidermal barrier between the outside and the inside; of the skin doing something other than it should do (slime-producing skin defines the X-File alien), or of the mucus of the body's interior leeching out onto the epidermal exterior." [7] It is true that the oozing liquid could be seen as a particularly glutinous kind of sweat, puddling up around the body. [8] Yet the woman's pose suggests nothing so much as that of an artist's model, and the viscous stuff through which we perceive her could equally well have come from *outside* the body, a surrogate for the paint with which she will be depicted. For Clayson, however, if the liquid is external, then it must be read as semen, "because semen lurks in the background of every honest effort to discuss other avatars of slime on the body. This assumes of course that the only way to explain the sight of a female body embellished by slime is to see it as having been acted on by another, a male other." [9]

The rhetoric of painting as a more or less aggressive action carried out by an always implicitly male artist upon a passive recipient is closely related to the model proposed by Rosenberg, in which the primed surface of the canvas receives the artist's spontaneous out- bursts, in the process going from virginal white to tarnished polychrome, covered in smeared and even thrown paint. As Rosenberg describes it: "The painter no longer approached his easel with an image in his mind; he went up to it with material in his hand to do something to that other piece of material in front of him." [10] The drips that run down the surface of the painting are the trace of the artist's quasi-orgasmic release, the evidence that he has "done something" to whatever stands in front of him. The painting is the residue of a struggle with archetypes, the unconscious, and with authenticity. The painter has to surrender himself completely to the ecstasy of the process. The point of comparison is clear when we recall Dunning's comment on the related *Puddle* pieces: that "for me this work is about the idea of being overwhelmed by and enveloped in something, of completely losing yourself in something." [11] And the difference is equally clear. In one case the protagonist (the artist) *projects* his (sic) ecstasy onto something (or, implicitly, someone) else. In the other the ecstasy involves the surrender of the protagonist's own body to envelopment. Dunning takes this dichotomy to a hilarious apogee in *Sundae I* (1997) [fig. 13], in which a woman's face is covered in a huge mound of whipped cream, on top of which sits a cherry.

In *Untitled Splatter* (1994) [fig. 14], Dunning does take material in her hand and do some- thing to another piece of material. Throwing tomatoes at a white wall is a parodic reenactment of the rhetoric of action painting. The resulting marks and stains carry all the signifiers of spontaneity and authenticity found in expressionistic painting, yet the viscerally organic quality of the overripe tomatoes sends the frame of reference lurching sideways into the realm of the body. *Splatter* is less a manifestation of the unconscious than it is an eruption of inappropriate physicality. The white carpet where most of the pulp ends up is testament not to the Platonic white cube of the exhibition space but to a ruined domestic environment. The drips suggest unfortunate leaking at least as much as spontaneous gesture. They recall the otherwise quite different series of *Flaws* [fig. 15] that Dunning made in 1992. These works focused on flaws that mark the surface of the body: moles, hairs, etc. Conventionally unmentionable as they might be, it was the very specificity of these flaws that gave these latex pieces their disturbingly real

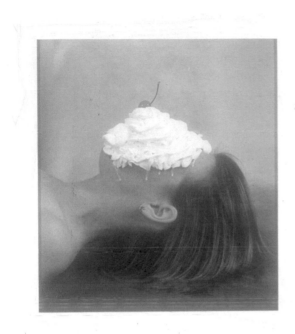

Fig. 13. *Sundae 1*, 1997

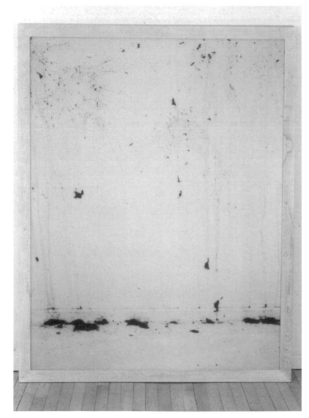

Fig. 14. *Untitled Splatter*, 1994

quality. Although no gender is specifically indicated for these flawed bodies, they read as women's bodies nevertheless, because it is (still) the norm that women's bodies are expected—almost *required*—to be perfectly flawless, and the presumption remains that this kind of scrutiny would be primarily directed at a woman's body. The drips in *Splatter* thus represent an undesirable but undeniable imperfection, even as they also lay claim to a symbol of painterly authenticity.

What is more, the inescapable violence of *Splatter*'s scenario is emblematic of Dunning's broader challenge to painting's authority. Despite the many such challenges to this authority since the invention of photography in the mid-nineteenth century, painting has been astonishingly successful in retaining a position of implicit superiority to all other media. While many painters have taken the repeated crises of painting seriously, and addressed them in their work, such practice has always been accompanied by waves of conservative reaction in defense of painting's patriarchal authority. As Benjamin Buchloh has described such movements, "The key terms of this ideological backlash are the idealization of the perennial monuments of art history and its masters, the attempt to establish a new aesthetic orthodoxy, and the demand for respect for the cultural tradition."[12] *Splatter* lays claim to the authenticity associated with the Abstract Expressionist gesture, and at the same time—in its despoiled living room—makes an equal claim to the kind of bad-boy transgression best exemplified by Jackson Pollock's drunken acting out. And Dunning does all this with a photograph, not another painting, thus denying this tradition even its literal and fetishistic relationship with paint itself.

For Clement Greenberg, famously, the essential attribute of painting was its flatness. This he identified as the quality that must be addressed by the most serious practitioners of the art. "The ineluctable flatness of the surface," he wrote, was "more fundamental than anything else to the processes by which pictorial art criticized and defined itself under Modernism.

For flatness alone was unique and exclusive to pictorial art. . . . Modernist painting oriented itself to flatness as it did to nothing else."[13] A photograph, however, is flatter than almost any painting. In Greenberg's model, the taut, paint-covered skin of the canvas must be *idealized* into a purely two-dimensional surface, regardless of any excrescences or lumps of paint that might seem to contravene the rule. Dunning's *Flaws* draw attention to just this kind of thing-that-must-be-overlooked.

The question of skin in general is one that she has returned to many times. In *Extra Skin (Adding)* (1999) [plate 42], the artist adds layers and layers of clothing to push the outer limits of her body into more and more space. As the body moves outwards, it reminds us that real skin is only notionally two-dimensional, that in fact it is merely the outermost layer of a roiling and fleshy three-dimensionality. The changing presence of the body raises questions of identity that go beyond the physical. As Dunning recognizes, people can understand themselves as subjects, and as objects, but holding both concepts in the mind at the same time can be hard.

Extra Skin (Adding), of course, makes Dunning look fat. And fat is a feminist issue. In a review of Dunning's *Blob* works [plates 25–30], Leslie Camhi made this point through the rhetoric of a stand-up comedian:

> An amorphous, flesh-toned blob holds center stage in Jeanne Dunning's new show of photography and videos. . . . A video monitor shows it jiggling on a bed, as for several minutes a woman struggles to dress it in a floral wrap skirt and lime-green top.
>
> Do I need art to remind me of this? Couldn't I just look in the mirror?[14]

The inescapably comical exaggeration of the *Blobs* has a more serious and not perhaps immediately evident counterpart in the thin, skinlike fabric that Dunning has sometimes used to frame the installation of her work [fig. 16]. These curtains not only frame; they also conceal. They require the viewer to move through them in order to see the work behind. Always, we are reminded that we experience the tactility of the world through our skin, that our skin is penetrable, and that it represents only the thin crust over a glutinous depth. The viewer is gently jostled between skin as pure surface and skin as container.

In a text of 2000, Dunning asked the question, "How can I see myself? If I could get outside of myself to see myself, what would there be to see?" *Extra Skin (Adding)* is in part an exploration of these questions. In her text, Dunning answers: "Empty flesh. Skin as superficial surface."[15] While in one sense, "superficial" simply *means* surface, it carries as well a freight of value-laden connotations, all of them negative. If something is superficial it is trivial, slight, not thought through. It lacks substance, in all the senses of *that* word. It is shallow; it has no depth. Dunning self-consciously plays with these connotations: skin and surface as Platonically two-dimensional, as the immaculate gloss over pulpy organs; and as superficial, insubstantial, simply not worth much. As Dunning asked, "If I could shed my skin like a snake and it held a memory of my shape, could I get a glimpse of myself, would it work like a shadow or a trace, or just a husk?"[16]

The potential penetrability—and hence depth—of skin was thoroughly explored in the *Hand Hole* works of the nineties, whose title puns on various kinds of intimacy. Making use of the same strategy that informed the *Untitled Landscapes,* the photographs reveal and withhold

Fig. 15. *Flaw*, 1992 (detail)

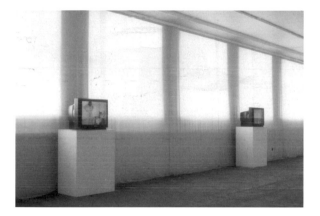

Fig. 16. Installation view, Konstmuseet, Malmö, Sweden, 1999

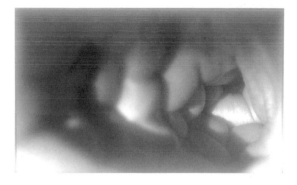

Fig. 17. *Hand Cavern*, 1997

just enough information to ensure at least a moment or two of confusion. In works such as *Hand Cavern* (1997) [fig. 17], the skin of the hand converts its two-dimensionality into a recessive embodiment of depth, reminding us that the body itself plays this trick everywhere the skin recedes into the body that it supposedly covers, surface becoming orifice. The erotic and fetishistic fascination widely associated with every orifice of the body suggests the inherently uncanny nature of this moment when the two-dimensional converts itself into depth. The tubes of receding flesh formed by the hands in Dunning's photographs invite the viewer to risk a series of vertiginous visual plunges into a visceral three-dimensionality that suggests a considerably greater degree of intimacy than simply holding hands. The seductive depth of the hands in the *Hand Holes* seems almost a deliberate rebuttal to the Greenbergian idea of flatness. The surface of the photographs quickly and willingly yields to the representation of fleshy depth.

For Greenberg, flatness was decisively associated with an idea of purity. Each art form was called upon to separate itself in chaste isolation from potential contamination by any other form: "The task of self-criticism became to eliminate from the specific effects of each art any and every effect that might conceivably be borrowed from or by the medium of any other art. Thus would art be rendered 'pure,' and in its 'purity' find the guarantee of its standards of quality as well as of its independence."[17] The direct sexual innuendo of the *Hand Hole* photographs marks a rejection not just of the cult of flatness, but also of the "purity" associated with it.

The complexity of Dunning's photographs lies in part in the contradictory elements that she puts into play with them. She shows us an array of slimy, gooey things, but in the form of photographs, so that a certain distance is introduced. The photographs themselves are fused flat to Plexiglas so that they are hard, shiny, and rigid. The material form of the work thus stands in a degree of contrast with the subject

matter. As Dunning has said, "The work often takes categories of things that seem mutually exclusive or distinct from each other, if not literally opposite, and blurs the boundaries between them."[18] She is talking here primarily about the *content* of her images, but the impulse to force together things that seem irreconcilable could also apply to the images themselves: hard, flat surfaces that invoke a world of endlessly tactile sliminess.

1 Maurice Merleau-Ponty, "Cézanne's Doubt," in *Sense and Non-Sense* (Chicago: Northwestern University Press, 1964), 17.
2 Interview with Mimi Thompson, in *Jeanne Dunning* (New York: Feigen, 1997), 18.
3 Interview with Thompson, 21.
4 Harold Rosenberg, "The American Action Painters" (1952), in *Art in Theory, 1900–1990,* edited by Charles Harrison and Paul Wood (Oxford: Blackwell, 1992), 583, 584.
5 Vasily Kandinsky, *Concerning the Spiritual in Art* (New York: Wittenborn, 1947).
6 Annalee Newman, quoted by Richard Shiff in "Whiteout: The Not-Influence Newman Effect," in *Barnett Newman,* edited by Ann Temkin (Philadelphia: Philadelphia Museum of Art, 2002), 104.
7 Hollis Clayson, "Slime," in Jeanne Dunning et al., *Show and Tell* (Chicago: self-published, 2001), 95.
8 My computer's spell-checker immediately suggested "pudding" for "puddling," which is no doubt appropriate.
9 Clayson, "Slime," 94.
10 Rosenberg, "The American Action Painters," 581.
11 Interview with Thompson, 21.
12 Benjamin Buchloh, "Figures of Authority, Ciphers of Regression: Notes on the Return of Representation in European Painting," in *Modernism and Modernity,* edited by Buchloh, Serge Guilbaut, and David Solkin (Halifax: Press of the Nova Scotia School of Art and Design, 1983), 85.
13 Clement Greenberg, "Modernist Painting" (1960), in *The Collected Essays and Criticism, Vol. 4: Modernism with a Vengeance, 1957–1969,* edited by John O'Brian (Chicago: University of Chicago Press, 1986), 87.
14 Leslie Camhi, "Return of the Blob, The Body Oozes Out of Bounds," *The Village Voice,* February 15, 2000, 69.
15 Dunning, in *Jeanne Dunning* (New York: Feigen, 2000), 3.
16 Dunning, in *Jeanne Dunning,* 3.
17 Greenberg, "Modernist Painting," 86.
18 Interview with Thompson, 18.

The exhibition is organized in sections that position Jeanne Dunning's work in relation to three traditional genres: (I) Landscape, (II) Still Life, and (III) Portraiture. The following checklist and corresponding plates (1–44) in the catalog reflect these divisions.

Dimensions are in inches; height precedes width.

I.

[1]
Untitled Landscape I
1987
Laminated C-print and frame
14 x 20
Edition of 3
Courtesy of Harris Theater for Music and Dance, Chicago IL

[2]
Untitled Landscape II
1987
Laminated C-print and frame
17 x 25
Edition of 3
Collection of Clayton Press and Gregory Linn

[3]
Study after "Untitled Landscape," 1987
1987
Black-and-white photograph and frame
12 x 13
Courtesy of Lys Martin

[4]
Study after "Untitled Landscape," 1987
1987
Black-and-white photograph and frame
12 x 13
Collection of Clayton Press and Gregory Linn

[5]
Study after "Untitled Landscape," 1987
1987
Black-and-white photograph and frame
12 x 13
Collection of the Museum of Contemporary Art, Chicago

[6]
Study after "Untitled Landscape," 1987
1988
Black-and-white photograph and frame
12 x 13
Courtesy of the artist

[7]
Study after "Untitled Landscape," 1987
1990
Black-and-white photograph and frame
12 x 13
Collection of Peter Norton, Santa Monica

[8]
Study after "Untitled Landscape," 1987
1994–95
Black-and-white photograph and frame
12 x 13
Courtesy of the artist

[9]
Study after "Untitled Landscape," 1987
1996
Black-and-white photograph and frame
12 ¾ x 13 ¾
Courtesy of the artist

[10]
Study after "Untitled Landscape," 1987
1996
Black-and-white photograph and frame
12 ¾ x 13 ¾
Collection of Marty and Rebecca Eisenberg

[11]
Study after "Untitled Landscape," 1987
1996
Black-and-white photograph and frame
12 ¾ x 13 ¾
Courtesy of Friedrich Petzel, New York

[12]
The Brown
1996
Cibachrome mounted to Plexiglas
and frame
73 ½ x 51 ½
Edition of 3
Courtesy of the artist and Feigen
Contemporary, New York

[13]
The Pink
1996
Cibachrome mounted to Plexiglas
and frame
73 ½ x 51 ½
Edition of 3 with 1 proof
Courtesy of the artist

[14]
The Red
1996
Cibachrome mounted to Plexiglas
and frame
73 ½ x 51 ½
Edition of 3
Courtesy of the artist and Feigen
Contemporary, New York

[15]
The White
1996
Cibachrome mounted to Plexiglas
and frame
73 ½ x 51 ½
Edition of 3
Courtesy of the artist and Feigen
Contemporary, New York

[16]
The Yellow
1996
Cibachrome mounted to Plexiglas
and frame
73 ½ x 51 ½
Edition of 3
Courtesy of the artist and Feigen
Contemporary, New York

II.

[17]
Sample
1990
Cibachrome mounted to Plexiglas
and frame
23 ½ x 16 ¾
Edition of 3
Collection of Marty and Rebecca
Eisenberg

[18]
Sample 3
1990
Cibachrome mounted to Plexiglas
and frame
18 x 15
Edition of 3
Courtesy of the Carol and Arthur
Goldberg Collection

[19]
Detail 8
1991
Laminated Cibachrome and frame
21 ½ x 17
Edition of 2
Collection of Maria Makela and
Neal Benezra

[20]
Detail 9
1991
Laminated Cibachrome and frame
21 ½ x 17
Collection of Sandy Golden

[21]
Detail 14
1992
Laminated Cibachrome and frame
21 ½ x 17
Collection of The Milwaukee Art
Museum, Ethel and Richard Herzfeld
Collection, M1992.243

[22]
Untitled Hole
1992
Cibachrome mounted to Plexiglas
and frame
39 x 38
Edition of 3
Courtesy of the artist

[23]
Untitled Hole
1992
Cibachrome mounted to Plexiglas
and frame
39 ½ x 38
Edition of 3
Courtesy of the artist

[24]
Untitled Part
1993
Cibachrome mounted to Plexiglas
and frame
33 x 23 ½
Edition of 3
Courtesy of the artist

[25]
The Blob 1
1999
Ilfochrome mounted to Plexiglas
and frame
52 x 37 ¼
Edition of 5
Courtesy of the artist

[26]
The Blob 2
1999
Ilfochrome mounted to Plexiglas
and frame
30 ¼ x 41 ¼
Edition of 5
Courtesy of the artist and Feigen
Contemporary, New York

[27]
The Blob 3
1999
Ilfochrome mounted to Plexiglas
and frame
34 ½ x 49 ½
Edition of 5
Courtesy of the artist

[28]
The Blob 4
1999
Ilfochrome mounted to Plexiglas
and frame
Edition of 5
37 x 48 ¾
Collection of the Museum of
Contemporary Photography,
Columbia College Chicago

[29]
In the Bathtub 1
1999
Ilfochrome mounted to Plexiglas
and frame
33 1/2 x 52 1/4
Edition of 5
Courtesy of the artist

[30]
On a Platter
1999
Ilfochrome mounted to Plexiglas
and frame
51 1/4 x 32 1/4
Edition of 5
Courtesy of the artist and Feigen
Contemporary, New York

III.

[31]
Untitled
1988
C-print and frame
15 x 12
Courtesy of Martin and Danielle
Zimmerman

[32]
Untitled
1988
C-print and frame
15 x 12
Courtesy of Martin and Danielle
Zimmerman

[33]
Untitled
1988
C-print and frame
15 x 12
Courtesy of Martin and Danielle
Zimmerman

[34]
Untitled
1988
C-print and frame
15 x 12
Courtesy of Martin and Danielle
Zimmerman

[35]
Untitled
1988
C-print and frame
15 x 12
Courtesy of Martin and Danielle
Zimmerman

[36]
Untitled
1988
C-print and frame
15 x 12
Courtesy of Martin and Danielle
Zimmerman

[37]
Head 2
1989
Laminated Cibachrome mounted
on Plexiglas
28 1/4 x 19
Edition of 2 with 1 proof
Collection of University Galleries,
Illinois State University, Normal

[38]
Head 3
1989
Laminated Cibachrome mounted
on Plexiglas
26 x 18 5/8
Collection of the Museum of Contemporary
Art, Chicago, partial and promised gift
from the Howard and Donna Stone
Collection

[39]
Head 6
1989
Laminated Cibachrome mounted
on Plexiglas
30 x 19
Edition of 2 with 1 proof
Courtesy of the Carol and Arthur
Goldberg Collection

[40]
Head 8
1990
Laminated Cibachrome mounted
on Plexiglas
30 x 19
Edition of 2 with 1 proof
Courtesy of the Broido Family Collection

[41]
Head 10
1990
Laminated Cibachrome mounted
on Plexiglas
26 1/2 x 18
Edition of 2 with 1 proof
Collection of Gloria and Paul Sternberg, Jr.

[42]
Extra Skin (Adding)
1999
Video
11:30 min.
Edition of 6
Courtesy of the artist

[43]
Extra Skin (Subtracting)
1999
Video
9:57 min.
Edition of 6
Courtesy of the artist

[44]
Trying to See Myself
1999
Video
16:54 min.
Edition of 6
Courtesy of the artist

Numbers preceding entry correspond to
figure/page numbers in catalog.

1/67
Edward Weston
Nude, 1925
Posthumous reproduction from
original negative
Edward Weston Archive, Center for
Creative Photography, University of Arizona
© 1981 Arizona Board of Regents

2/67
Edward Weston
Artichoke Halved, 1930
Gelatin silver print, 7 ½ x 9 ½
Collection Center for Creative Photography,
University of Arizona
© 1981 Arizona Board of Regents

3/69
Robert Mapplethorpe
Livingston, 1988
Silver print, 24 x 20
© The Robert Mapplethorpe Foundation
Courtesy Art + Commerce

4/69
Michael Kenna
*Hilltop Trees, Study 2, Teshikaga, Hokkaido,
Japan, 2004,* 2004
Sepia toned gelatin silver print, 7 ½ x 7 ½
Courtesy of the artist and Stephen Wirtz
Gallery, San Francisco

5/71
Hand Hole, 1994
Cibachrome mounted to Plexiglas and
frame, 29 ½ x 27 ½
Edition of 3
Courtesy of the artist

6/71
Red Detail, 1990
Cibachrome mounted to Plexiglas and
frame, 40 ¾ x 27 ½
Edition of 3
Courtesy of the artist

7/72
Emiko Kasahara
Pink (#1), 1997
Cibachrome, 50 x 62 each (9 prints)
Courtesy of the artist and Yoshiko Isshiki
Office

8/72
Jenny Saville, Glen Luchford
Closed Contact #10, 1995–96
C-print mounted in Plexiglas, 96 x 72 x 6
Courtesy of Gagosian Gallery

9/73
Pinar Yolacan
Untitled, 2002
C-print, 30 x 40
Courtesy of the artist and Rivington Arms

10/73
Allan deSouza
Terrain #5, 1999
C-print on aluminum, 24 x 18 ½
Courtesy of the artist and Talwar Gallery,
New York

11/83
The Edible 1, 1997
Cibachrome mounted to Plexiglas and
frame, 32 x 26
Edition of 5
Courtesy of the artist

12/83
Untitled with Food, 1996
Cibachrome mounted to Plexiglas and
frame, 42 ¼ x 28 ¼
Edition of 3
Courtesy of the artist

13/85
Sundae 1, 1997
Cibachrome mounted to Plexiglas and
frame, 24 ¾ x 22 ½
Edition of 5
Courtesy of the artist

14/85
Untitled Splatter, 1994
Cibachrome mounted to Plexiglas and
frame, 67 ¼ x 52 ¼
Edition of 2
Courtesy of the artist

15/87
Flaw, 1992
Latex, 14 ½ x 14 ½
Courtesy of the artist

16/87
Installation view, 1999
Konstmuseet, Malmö, Sweden
Courtesy of the artist

17/87
Hand Cavern, 1997
Cibachrome mounted to Plexiglas and
frame, 24 ½ x 38
Edition of 5
Courtesy of the artist

Cover and plates 6, 8, and 9
photographed by Ben Blackwell.

ONE-PERSON EXHIBITIONS

1987
Feature, Chicago

1988
Feature, Chicago

1989
Feature, New York

1990
Real Art Ways, Hartford, Connecticut
Roy Boyd Gallery, Santa Monica, California
Feature, New York
Southern Exposure, San Francisco

1991
Jeanne Dunning: Bodies of Work, Illinois State
 University Galleries, Normal, Illinois
Galleria Massimo De Carlo, Milan
Galerie Samia Saouma, Paris
Feature, New York
Feigen, Inc., Chicago

1992
Esther Schipper, Cologne
Feature, New York
Feigen, Inc., Chicago
Roy Boyd Gallery, Santa Monica, California

1993
Galerie Samia Saouma, Paris

1994
Hirshhorn Museum and Sculpture Garden, Smithsonian
 Institution, Washington, D.C.; traveled to the Museum
 of Contemporary Art, Chicago
Feature, New York
Feigen, Inc., Chicago

1995
Richard Telles Fine Art, Los Angeles
Galleria Massimo De Carlo, Milan
Rena Bransten Gallery, San Francisco

1996
Anthony D'Offay Gallery, London
Feigen, Inc., Chicago
Galerie Samia Saouma, Paris

1997
Feigen Contemporary, New York
Tomio Koyama Gallery, Tokyo
Richard Telles Fine Art, Los Angeles
Institute of Visual Arts (INOVA), University of Wisconsin,
 Milwaukee

1998
Galleria Massimo De Carlo, Milan
M du B, F, H & G, Montréal, Québec

1999
Konstmuseet, Malmö, Sweden

2000
Magazin 4 Vorarlberger Kunstverein, Bregenz, Austria
Feigen Contemporary, New York
Tomio Koyama Gallery, Tokyo
James Harris Gallery, Seattle

2001
Bodybuilder and Sportsman, Chicago

2002
Tom Thumb: Notes Towards a Case History (Web-based project),
 Dia Center for the Arts, New York
James Harris Gallery, Seattle
Feigen Contemporary, New York

2004
Feigen Contemporary, New York
The Suburban, Oak Park, Illinois

2005
Galleria Massimo De Carlo, Milan

GROUP EXHIBITIONS

1986
Dull Edge, Randolph Street Gallery, Chicago

1987
The Hallucination of Truth, P.S.1, Long Island City, New York
Anxious Objects, Illinois State University Galleries, Normal,
 Illinois
The Non-Spiritual in Art: Abstract Painting 1985-????, Chicago
Signs of Intelligent Life, Greathouse, New York

1988
Sex, Death, and Jello, Randolph Street Gallery, Chicago
New Strategies, Jan Kesner Gallery, Los Angeles
Looking Out: The Rockford Art Museum Regional, Rockford Art
 Museum, Rockford, Illinois

1989
The Photography of Invention: American Pictures of the 1980s,
 The National Museum of American Art, Washington, D.C.;
 traveled to the Museum of Contemporary Art, Chicago;
 and the Walker Art Center, Minneapolis
A Certain Slant of Light: Contemporary American Landscape,
 Akron Art Museum, Akron, Ohio
The Unconventional Landscape, John Michael Kohler Art
 Center, Sheboygan, Wisconsin
Materiality, CEPA Gallery, Buffalo, New York

1990
On the Road (public project on Chicago buses), Art Against
 AIDS
Your Message Here (exhibition of billboards), Randolph Street
 Gallery, Chicago
New Generations: Chicago, Carnegie Mellon Art Gallery,
 Pittsburgh

1991
The Whitney Biennial, The Whitney Museum of American Art,
 New York
Wealth of Nations, Centrum Sztuki Wspolczesnej Zamek
 Ujazdowski, Warsaw, Poland
*Just What Is It That Makes Today's Homes So Different,
 So Appealing?,* The Hyde Collection, Glen Falls, New York
Stillstand Switches, Shedhalle, Zurich

1992
Dirty Data: Sammlung Schürmann, Ludwig Forum für
 Internationale Kunst, Aachen, Germany
The Red Light Show, CASCO, Utrecht, The Netherlands
Twenty Fragile Pieces, Galerie Analix, Geneva
Hair, John Michael Kohler Art Center, Sheboygan, Wisconsin
Documentario, Milan
Object Choice, Hallwalls, Buffalo, New York

1993
Sensual Disturbance: Judie Bamber and Jeanne Dunning,
 Tyler School of Art, Temple University, Philadelphia
Restaurant, La Bocca, Paris
Picturing Ritual, Center for Photography at Woodstock, New
 York; traveled to Neuberger Museum, Purchase, New York
The Return of the Cadavre Exquis, The Drawing Center,
 New York; traveled
Changing I: dense cities, Shedhalle, Zurich
Vivid, Raab Galerie, Berlin; traveled to Raab Boukamel Galleries,
 London; and Gian Ferrari Arte Contemporanea, Milan
Galerie Walcheturm, Zurich

1994
Temporary Translations(s): Sammlung Schürmann, Deichtorhallen,
 Hamburg
Bad Girls, The New Museum of Contemporary Art, New York
Bad Girls West, UCLA Wight Art Gallery, Los Angeles
Oh Boy, It's a Girl!, Kunstverein Munich, Germany; traveled to
 Kunstraum, Vienna
Existence and Gender: Women's Representation of Women,
 organized by USIS, traveled in Japan to Aka Renga Bunkakan,
 Fukuoka; Kyoto International Community House, Kyoto;
 Aichi Prefectural Arts Center, Nagoya; Osaka Prefectural
 Contemporary Arts Center, Osaka; Spiral/Wacoal Arts
 Center, Tokyo; and Recent Gallery, Sapporo
*Correspondences / Korrespondenzen: Fourteen Artists from Berlin
 and Chicago,* Berlinische Galerie, Museum für Moderne
 Kunst, Photographie und Architektur, Berlin; traveled to
 The Cultural Center, Chicago
Pictures of the Real World (In Real Time), Paula Cooper Gallery,
 New York; traveled
Don't Look Now, Thread Waxing Space, New York

1995

Identity and Alterity, Venice Biennale, Venice
Feminimasculin· Le sexe de l'art, Centre Georges Pompidou, Paris
Micromegas, The American Center, Paris; traveled to The Israel
 Museum, Jerusalem
La Belle et La Bête, Musée d'Art Moderne de la Ville de Paris, Paris
On Beauty, Regina Gallery, Moscow
Traces: The Body in Contemporary Photography, The Bronx
 Museum of Art, Bronx, New York
Inscrutable Objects, The Ansel Adams Center for Photography,
 San Francisco

1996

Tenth Biennale of Sydney, The Art Gallery of New South
 Wales, Sydney
Art in Chicago, 1945–1995, Museum of Contemporary Art, Chicago
Sammlung Vollkmann zeigt: Faustrecht der Freiheit, Kunstsammlung
 Gera, Gera, Germany; traveled to Neues Museum Weserburg,
 Bremen, Germany
Up Close and Personal, Philadelphia Museum of Art, Philadelphia
Declinaison, Frac Languedoc-Roussillon, Montpellier, France
Monstrosities 1/2, Galerie Arndt, Berlin
Shots of Normality, Galerie der Stadt Schwaz, Schwaz, Austria
Inbetweener, Center for Contemporary Arts, Glasgow

1997

Defining Eye: Women Photographers of the 20th Century,
 The Saint Louis Art Museum, Saint Louis, Missouri;
 traveled to The Museum of Fine Arts, Santa Fe; The Mead
 Museum of Art, Amherst, Massachusetts; The Wichita Art
 Museum, Wichita, Kansas; and The Armand Hammer
 Museum, University of California, Los Angeles
The Body in the Lens, The Montréal Museum of Fine Arts,
 Montréal
Indelicacies / Exquises duplicités, La Centrale, Montréal
Slad, Apex Art, New York
Été 97, Centre genevois de gravure contemporaine, Geneva
Heaven, P.S.1, Long Island City, New York

1998

New Photography 14, The Museum of Modern Art, New York
Love's Body: Rethinking Naked and Nude in Photography,
 The Metropolitan Museum of Photography, Tokyo;
 traveled to Suntory Museum, Osaka
Pop Surrealism, The Aldrich Museum of Contemporary Art,
 Ridgefield, Connecticut
Mysterious Voyages, Contemporary Museum at the Alex Brown
 Building, Baltimore
Icing, Sandberg2, The Sandberg Institute, Amsterdam

1999

The Nude in Contemporary Art, The Aldrich Museum,
 Ridgefield, Connecticut

2000

Presumed Innocent, Musée d'art contemporain de Bordeaux,
 France
Rapture, MassArt, Boston

2001

Ohne Zögern: Sammlung Olbricht Teil 2, Neues Museum
 Weserberg, Bremen, Germany
Les Voluptes, Borusan Kültur ve Sanat, Istanbul

2002

Life Death Love Hate Pleasure Pain, The Museum of
 Contemporary Art, Chicago

2003

Here Is Elsewhere, The Museum of Modern Art, New York
Love Planet, Naoshima Contemporary Art Museum,
 Okayama, Japan
False Innocence, Fundació Joan Miró, Barcelona

2004

Speaking with Hands, Solomon R. Guggenheim Museum,
 New York
Identity II: Self-Scrutiny, Nichido Contemporary Art, Tokyo
Aldrich at the Movies (artists' video works shown as short
 subjects at area cinemas), Aldrich Contemporary Art
 Museum, Ridgefield, Connecticut
Hair: Untangling a Social History, The Frances Young Tang
 Teaching Museum and Art Gallery at Skidmore College,
 Saratoga Springs, New York
Filling Up/Spilling Out, Palm Beach Institute of Contemporary
 Art, Lake Worth, Florida
Why Not Live for Art?, Tokyo Opera City Art Gallery, Tokyo

2005

Can You See the Real Me?, Württembergischer Kunstverein,
 Stuttgart, Germany
Some Versions of the Portrait, International Center of Photography,
 New York

BOOKS AND CATALOGS

Aletti, Vince. *Dormir/Sleep*. Paris, Geneva, New York: Cromandel Press, 2001, 144–45.

Armstrong, Richard, et al. *1991 Biennial Exhibition*. New York: The Whitney Museum of American Art, 1991.

Barak, Ami, and David G. Torres. *False Innocence*. Barcelona: Fundació Joan Miró, 2003.

Basha, Regine, and Jeanne Dunning. *Jeanne Dunning*. New York: Feigen Contemporary, 2000.

Bernadac, Marie-Laure, et al. *Feminimasculin: Le sexe de l'art*. Paris: Centre Georges Pompidou and Gallimard/Electra, 1995.

———. *Présumés innocents, L'art contemporain et l'enfance*. Bordeaux: cpacMusée d'art contemporain de Bordeaux, 2000.

Blessing, Jennifer. *Speaking with Hands: Photographs from the Buhl Collection*. New York: Solomon R. Guggenheim Museum, 2004.

Blinderman, Barry, Laurie Palmer, and Matias Viegener. *Jeanne Dunning: Bodies of Work*. Normal: University Galleries of Illinois State University, 1991.

Cooke, Lynne. *Jurassic Technologies Revenant: 10th Biennale of Sydney, 1996*. Sydney: Biennale of Sydney, 1996.

Cotton, Charlotte. *The Photograph as Contemporary Art*. London: Thames and Hudson Ltd., 2004.

Cruz, Amada. *Directions: Jeanne Dunning*. Washington, D.C.: Hirshhorn Museum and Sculpture Garden, 1994.

Dirty Data: Sammlung Schürmann 1992. Aachen, Germany: Ludwig Forum für Internationale Kunst, 1992.

Ewing, William A. *Love and Desire: Photoworks*. San Francisco: Chronicle Books, 1999.

Ferris, Alison. *Hair*. Sheboygan, WI: John Michael Kohler Art Center, 1993.

Hickey, Dave, and Judith Russi Kirshner. *Subjective Realities: Works from the Refco Collection of Contemporary Photography*. Chicago: Refco Group, Ltd., 2003.

Gumpert, Lynn. *La Belle et La Bête*. Paris: Paris Musées, Editions des musées de la ville de Paris, 1995.

Kasahara, Michiko, Chizuko Ueno, and Toshimaru Ogura. *Love's Body: Rethinking Naked and Nude in Photography*. Tokyo: Tokyo Metropolitan Museum of Photography, 1999.

Lahs-Gonzales, Olivia, and Lucy Lippard. *Defining Eye: Women Photographers of the 20th Century: Selections from the Helen Kornblum Collection*. Saint Louis: The Saint Louis Art Museum, 1997.

Phelan, Peggy, and Helena Reckitt. *Art and Feminism*. London: Phaidon, 2001.

Romano, Gianni. *Contemporanee*. Milan: Costa & Nolan, 2000.

———. *Twenty Fragile Pieces*. Geneva: Galerie Analix - B & L Polla; Milan: Art Studio Edizioni, 1992.

Rüdinger, Ulrike, and Herbert Volkmann. *Sammlung Volkmann zeigt: Faustrecht der Freiheit*. Gera, Germany: Kunstsammlung Gera, 1996.

Saxenhuber, Hedwig, and Astrid Wege. *Oh Boy, It's a Girl!: Feminismen in der Kunst*. Munich: Kunstverein München, 1994.

Schoppmann, Wolfgang, ed. *Ohne Zögern: Sammlung Olbricht Teil 2*. Bremen: Neues Museum Weserburg; Heidelberg: Gesellschaft für Aktuelle Kunst in cooperation with Edition Braus, 2001.

Smith, Elizabeth A. T., Alison Pearlman, and Julie Rodriques Widholm. *Life Death Love Hate Pleasure Pain: Selected Works from the Museum of Contemporary Art, Chicago, Collection.* Chicago: The Museum of Contemporary Art, 2002.

Smith, Joshua P. *The Photography of Invention: American Pictures of the 1980s.* Washington, D.C.: National Museum of American Art; Cambridge, MA: The MIT Press, 1989.

Thompson, Mimi. *Jeanne Dunning.* New York: Feigen Contemporary, 1997.

Temporary Translation(s): Sammlung Schürmann. Hamburg: Deichtorhallen Hamburg, 1994.

Tucker, Marcia, Linda Goode Bryant, and Cheryl Dunye. *Bad Girls.* New York: The New Museum of Contemporary Art; Cambridge, MA: The MIT Press, 1994.

Varnedoe, Kirk, Paola Antonelli, and Joshua Siegel, ed. *Modern Contemporary: Art at MOMA Since 1980.* New York: The Museum of Modern Art, 2000.

ARTIST'S PROJECTS AND WRITINGS

Art Journal, Fall 1989, 254–55.

Artforum, May 1990, 165–67.

Artpaper, February 1989.

Du, June 1991, 42–45.

Dull Edge. Chicago: Randolph Street Gallery, 1986.

Frame-Work, Issue #3, 1991, 26–29.

"Getting to Know the Law or Making Things Mean What I Want Them to Mean or A Collection of Quotes I Like" (co-authored with Hirsch Perlman). *Dirty Data: Sammlung Schürmann.* Aachen, Germany: Ludwig Forum für Internationale Kunst, 1992, 50–57.

Heads. Self-published, 1989.

Show and Tell. Self-published, 2001.

Stuff. Chicago: The Contemporary Arts Council, 1999.

"Thoughts on Dirt. On Walter de Maria's *New York Earth Room* and Robert Smithson's *Partially Buried Woodshed.*" *Documents 23,* Spring 2004, 70–79.

Whitewalls, Winter 1989.

ARTICLES AND REVIEWS

Agboten-Jumeau, Jean-Charles. "Body Work." *Forum International,* September 1991, 83, 92.

Arning, Bill. "Camera Shy." *Time Out New York,* November 19–26, 1998, 63.

Artner, Alan G. *Chicago Tribune,* May 12, 1988, Section 5, 8.

———. "Video Violence Footnotes Dunning's Output." *Chicago Tribune,* April 15, 1994, Section 7, 62.

Auerbach, Lisa. "Jeanne Dunning at Richard Telles." *LA Weekly,* February 28, 1997, 55.

Barak, Ami. "Jeanne Dunning." *Art Press,* October 1991, 119.

Barckert, Lynda. "Sex, Death, Tomatoes." *Chicago Reader,* April 26, 1991, 45.

Barden, Lane. "Secretive Images." *Artweek,* June 18, 1992, 18.

Barrie, Lita. "Pleasure Subverted." *Artweek,* October 4, 1990, 14–15.

Bonesteel, Michael. "Medium Cool: New Chicago Abstraction." *Art in America,* December 1987, 139–147.

Brunetti, John. *Dialogue,* July/August 1990, 22–23.

Camhi, Leslie. "The Body Oozes out of Bounds." *Village Voice,* February 15, 2000, 69.

Clifford, Katy. "Jeanne Dunning." *Art News,* May 2000, 228.

Coleman, A. D. "Jeanne Dunning." *Art News,* December 1997, 165.

Cooke, Lynne. "Micromegas." *Parkett 44,* 1995, 132–45.

Damianovic, Maia. "Jeanne Dunning." *Tema Celeste,* August–September 1998, 50.

Decter, Joshua. *Arts Magazine,* Summer 1989, 93.

Fahey, Anna. "Jeanne Dunning." *Seattle Weekly,* October 9, 2000, 85.

———. "Jeanne Dunning." *Art Papers Magazine,* March/April 2001, 55.

Gerstler, Amy. "Jeanne Dunning." *Artforum,* November 1990, 174–75.

Glueck, Grace. "New Photography 14." *The New York Times,* October 30, 1998, B36.

———. "Jeanne Dunning." *The New York Times,* March 19, 2004, E35.

Hess, Elizabeth. "And Everything Nice?" *Village Voice,* February 1, 1994, 83.

———. "Upstairs, Downstairs." *Village Voice,* April 30, 1991, 93–94.

Heyler, Joanne. "Body Languages." *Los Angeles Reader,* May 22, 1992, 15.

Hixson, Kathryn. *Arts Magazine,* Summer 1990, 104–5.

——— "Cool, Conceptual, Controversial." *New Art Examiner,* May 1988, 30–33.

———. "Double Reverse Flip." *Arts Magazine,* December 1991, 42–45.

———. *Flash Art,* Summer 1991, 134–136.

Holliday, Taylor. "Nude Awakenings." *Art News,* February 1999, 94–95.

Hoving, Thomas. "World Class Art: Art for the Ages." *Cigar Aficionado,* Summer 1995, 214–226.

Humphrey, David. "Hair Piece." *Art Issues,* February 1990, 17–20.

Kandel, Susan. "Jeanne Dunning at Roy Boyd." *Art Issues,* September/October 1992, 43.

———. *Los Angeles Times,* February 23, 1995, F10.

———. "Representative Work from Jeanne Dunning." *Los Angeles Times,* May 22, 1992, F13.

———. *Arts Magazine,* December 1990, 109–10.

Kent, Sarah. "Jeanne Dunning." *Time Out Magazine,* June 5, 1996.

Kirshner, Judith Russi. *Artforum,* September 1992, 102–3.

Knight, Christopher. *Los Angeles Times,* September 14, 1990, F14.

Lewis, Jo Ann. "'Directions' Ripe for the Picking." *The Washington Post,* July 21, 1994, C6.

Mahoney, Robert. "Jeanne Dunning." *Time Out New York,* February 17–24, 2000, 59.

McCracken, David. "Double Takes." *Chicago Tribune,* March 31, 1991, Section 5, 3.

McWilliams, Martha. "Corporeal Punishment: Directions: Jeanne Dunning." *Washington D.C. City Paper,* September 2, 1994, 41.

Milbauer, Katie. "Jeanne Dunning." *Seattle Weekly,* May 23, 2002, 91.

Newhall, Edith. "Whose Blob Is It Anyway?" *New York,* February 14, 2000, 155.

Palmer, Laurie. "Jeanne Dunning: University Galleries of Illinois State University." *Flash Art,* 1991, 171.

Perchuk, Andrew. "Jeanne Dunning." *Artforum,* April 2000, 142.

Pultz, Shannon. "Jeanne Dunning." *Flash Art,* Summer 1995, 68–69.

Quinones, Paul. "Jeanne Dunning." *New Art Examiner,* June 2000, 39.

Raynor, Vivian. "The Figure from Twelve Earnest Viewpoints." *The New York Times* (Westchester Edition), July 13, 1995.

Reilly, Maura. "Jeanne Dunning at Feigen Contemporary." *Art in America,* July 2000, 103.

Riding, Alan. "The Living Arts: French Survey Sex in 20th-Century Art." *The New York Times,* November 7, 1995, C13, 17.

Rimanelli, David. "Time Capsules: 1986–1990." *Artforum,* April 2003, 97, 108.

Romano, Gianni. "Investigations: Jeanne Dunning." *Zoom Magazine,* no. 126, November/December 1993, 12.

Rugoff, Ralph. "'Dumb' Down and Under." *LA Weekly,* August 16, 1996, 43–44.

Servon, Jody. "Boundaries of the Body: Filling Up/Spilling Out." *NY Arts* (International Edition), May/June 2004, 42.

Seward, Keith. "Jeanne Dunning." *Artforum,* January 1995, 85–6.

Snodgrass, Susan. *New Art Examiner,* September 1989, 52–53.

Thompson, Mimi. *Bomb No. 60,* Summer 1997, 75–77.

Viegener, Matias. "Jeanne Dunning at Roy Boyd." *Art Issues,* December 1990, 43.

Warner, Marina. "Bush Natural/Wie die Wilden." *Parkett no. 27,* 1991, 6/12 ff.

Weil, Benjamin. *Flash Art,* October 1993, 79.

Wittig, Rob. "Anatomy of the Creeps." *Chemical Imbalance,* Summer 1992, 35–37.

——. "Jeanne Dunning at Roy Boyd." *Art in America,* January 1991, 142–43.

Yood, James. "Jeanne Dunning." *Artforum,* September 1996, 114–15.

——. *New Art Examiner,* February 1987, 47–48.

HEIDI ZUCKERMAN JACOBSON is director and chief curator of the Aspen Art Museum. From 1999 to June 2005, she was the Phyllis Wattis MATRIX Curator at the University of California, Berkeley Art Museum and Pacific Film Archive, where she curated more than forty solo exhibitions of international contemporary artists including Peter Doig, Tobias Rehberger, Shirin Neshat, Teresita Fernández, Julie Mehretu, Doug Aitken, Tacita Dean, Wolfgang Laib, Ernesto Neto, Simryn Gill, Sanford Biggers, and T. J. Wilcox. Jacobson has taught at UC Berkeley, CUNY Hunter College, and is on the faculty of California College of the Arts in the Masters of Curatorial Practice program.

RUSSELL FERGUSON is deputy director for exhibitions and programs and chief curator at the Hammer Museum, Los Angeles. Exhibitions he has organized include *In Memory of My Feelings: Frank O'Hara and American Art, Liz Larner,* and *Douglas Gordon* at The Museum of Contemporary Art, Los Angeles; *Open City: Street Photographs Since 1950* at The Museum of Modern Art, Oxford; and *Christian Marclay, The Undiscovered Country,* and *Patty Chang: Shangri-La* at the Hammer. He has written about the work of many contemporary artists, including Thomas Eggerer, Olafur Eliasson, Rodney Graham, Nikki Lee, Damian Ortega, Laura Owens, and Gillian Wearing.

28 June '06 Eastern Book Co. B '40 (20.04) 992 45